"This elegant and exhilarating little book is a rhapsodical roller coaster slung between eighteenth-century Paris and contemporary Manhattan with Antoine Watteau as its focal point. It swoops from Helen of Troy to Katharine Hepburn, Boucher to Beardsley and Beckett. In between these leaps and lunges it contemplates Watteau's paintings with an imaginative steadiness that quickens and clarifies their cloudy power."
—Hilary Spurling, author of *A Life of Henri Matisse*

"In prose as smooth as warm honey, Perl tells us what little there is to know about Watteau's life, describes his paintings and drawings, and moves from one odd little essay to another like a bumblebee lighting for a moment on this flower and then on that." —*Providence Journal*

"As suggestive, high-spirited and accomplished as one of Watteau's own compositions."
—*Milwaukee Journal Sentinel*

"Challenging, stimulating, enlightening. . . . Approached this way, dictionary-style, Watteau . . . emerges more distinctly—perhaps better than any standard narrative or critical biography could have rendered him."
—*The Plain Dealer*

Jed Perl

Antoine's Alphabet

Jed Perl was born in New York City and studied art history and painting at Columbia University. Since 1994 he has been the art critic at *The New Republic*. His books include *Paris Without End*, *Eyewitness*, and *New Art City: Manhattan at Mid-Century*. He lives in Manhattan.

ALSO BY JED PERL

Paris Without End

Gallery Going

Eyewitness

New Art City: Manhattan at Mid-Century

Antoine's Alphabet

ANTOINE'S ALPHABET

Watteau and His World

Jed Perl

Vintage Books
A Division of Random House, Inc.
New York

FIRST VINTAGE BOOKS EDITION, SEPTEMBER 2009

Copyright © 2008 by Jed Perl

All rights reserved. Published in the United States by Vintage Books,
a division of Random House, Inc., and in Canada by Random House of
Canada Limited, Toronto. Originally published in hardcover
in the United States by Alfred A. Knopf, a division of
Random House, Inc., New York, in 2008.

Vintage and colophon are registered trademarks of Random House, Inc.

The Library of Congress has cataloged the Knopf edition as follows:
Perl, Jed.
Antoine's alphabet : Watteau and his world /
by Jed Perl—1st ed.
p. cm.
1. Watteau, Antoine, 1684–1721. I. Title.
ND553.W3P28 2008
759.4—dc22 2008019371

Vintage ISBN: 978-0-307-38594-9

Author photograph © Marion Ettlinger
Book design by Anthea Lingeman

www.vintagebooks.com

To Deborah

And to Nathan and Jessie

> *Chaque coquillage incrusté*
> *Dans la grotte où nous nous aimâmes*
> *A sa particularité.*
>
> Paul Verlaine, "*Les Coquillages*"

Antoine's Alphabet

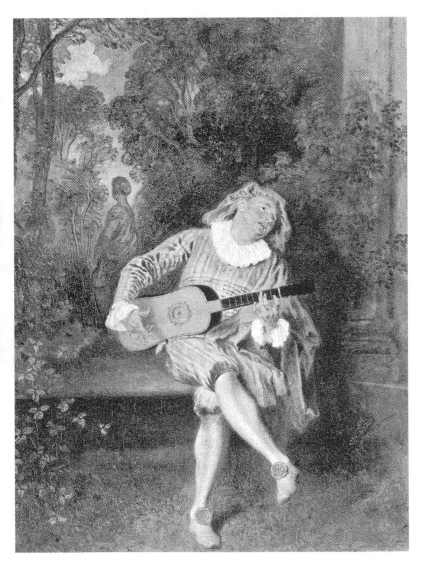

Watteau, *Mezzetin* (oil on canvas)

Prologue

He is a whirligig of a man—this elegant fellow, alone in a garden, dressed in an absurdly fancy outfit of blue-and-pink striped silk. He is an excitable dreamer, playing on his guitar and singing, his sleekly athletic presence jangled by a great restlessness or anxiety. Surely there is a somebody somewhere he adores, a woman suggested by the shadowy silhouette of a statue glimpsed just beyond his head. So he flings back that head of his and screws up his eyes, until one dark, off-center pupil becomes an addled bull's-eye, a heraldic device suggesting a lover's wild abandon in this nearly abandoned garden. Only the strongest of passions could explain the animation of his limbs, the pinwheel kaleidoscope of his fast-moving arms and legs, which vibrate with the energy of that strangest and finest of inventions, the human machine. The fingers of his left hand, pressing down on the strings of the neck of his guitar, are four essays in hyperbole, with each joint and muscle and sinew given its own twist, its own angle, its own corkscrew curve. His fingernails are punctuation marks, sharp and acute. And his legs, in breeches and white tights, crossed at the knee, explode in feet shod in slippers with pink rosettes, describing two points in the swing of a pendulum or two hours on a clock, the left, resting on the ground, marking 6:00, while

the right, floating in the air, is at 4:30. What time of day it actually is is hard to know, but then there is no time that would not be right for this explosive celebration of ardor, this apostrophe to the risks of feeling.

The mysterious young man, painted by Jean-Antoine Watteau in the early years of the eighteenth century, is a splendidly absurd mechanism dedicated to the idea of human feeling. The touch of Watteau's brush, the power of his conception, here and in another three dozen or so masterpieces, are a mingling of velvetiness and steeliness that constitute one of the miracles of art. I cannot get enough of the easy yet persuasive power of this work, so much so that whenever I'm asked to name my favorite painter I reply, without a moment's hesitation: "Watteau." But the reactions to this name, even among good friends, are not always simple. Some people are uneasy when they hear me mention an early-eighteenth-century artist whom they associate, if they have any associations at all, with lightly sentimental studies of lovers in overgrown parks. And indeed that is how some people would describe the figure in the painting with which we've begun, who is known as Mezzetin. I imagine that my choice of a favorite painter would be more readily accepted if I were to announce that my preference were for Rembrandt or Goya, or some other figure whose work has a certain darkness about it, whose themes are self-evidently large. When I single out Watteau, I may be perceived as toying with the question by putting this painter of Harlequins and Pierrots and amorous ambiguities at the top of my list. I may be perceived as being

somewhat sardonic, or ironic, or even impish when I say that Watteau is my favorite painter, as if I were trying to mock the question, or were hiding my true feelings behind a dandyish façade.

Watteau is surely a master of silken surfaces and elusive emotions, and if you are uncomfortable with this sort of playful visual luxuriance, you will not like Watteau. But for those of us who rank him among the greatest painters, the audacity with which he insists on hiding or veiling or theatricalizing strong feelings becomes a way of revealing the complexity of those feelings. Watteau's delicious artifice—the flickering brushwork, the evanescent colors, the casual yet definitive shape of his compositions—is calculated to ease us into the gathering contradictions of his world. We are never sure if Watteau's beloved young people, fine-boned, often a little childlike, are falling in love—or falling out of love. We aren't sure if they are actors and musicians, or aristocrats dabbling in the arts, or wealthy commoners who are playing at being aristocrats. Watteau's young people seem to want, above all else, to feel at ease, somewhat at ease, in an uneasy world. And the fans, the masks, the turned backs, the shadowy corners, all the props and situations of his art, become challenges, stimulants, provocations. The settings are more often than not versions of the same garden that we know from the painting of Mezzetin, elegant but somewhat down-at-the-heels gardens, with the vegetation grown slightly wild and the statues not in perfect repair, although sometimes we are in the colonnade of a grand house and sometimes, as in *The*

Pilgrimage to the Isle of Cythera, the scenery is less culti-vated and more expansive.

The repetition of elements in Watteau's paintings, each time with a slightly different emphasis, gives the work a mythical aura. Watteau, who was at once the most informal and the most insistent of mythologizers, may not have been especially interested in the old Ovidian stories, in all the tales of this or that god's or demigod's joys and trials and transformations, stories that had been so dear to the artists of the Renaissance. For Watteau, the mythology that mat-tered was infinitely more modern. This artist who said hardly anything about his paintings and struck most of his friends as something of a mystery man took as his essential subject the invention of self-consciousness, the struggle to feel fully alive. He painted women as beautiful as Daphne and men as handsome as Narcissus, and what they are laboring to become is their truer, unembarrassed selves. Watteau's lovers and dreamers are always fighting off the uncertainties of existence. And their doubts, clothed in the commedia dell'arte lightness of an improvisation or a folly, clearly touched a nerve in the early eighteenth century, when the rigidities of the ancien régime were beginning to be questioned. Watteau's work has always appealed to peo-ple who are at once in love with the beautiful surfaces of the world and suspicious of the ease with which they're seduced by a sun-dappled garden, a beautifully cut silk dress, the smiling eyes of a person they barely know. Surely it is something in the sneakiness of Watteau's seriousness that endeared him to nineteenth-century aesthetes, who yearned

to escape from the gathering homogenization of the Age of Industrialization. And no doubt it's the scintillating poetic ambiguity of Watteau's art that has made it feel like an oasis in our ever more technological age.

Watteau's enigmatic themes, which were being turned into formulas by his disciples even before his untimely death in 1721, have continually reasserted their power. It is these themes—and their significance, and what they have meant to artists and writers, and what they have meant to me—that have shaped the pages that follow, this gathering of people and ideas and impressions dedicated to Watteau. The subject is by its very nature capacious, for every sighing lover on a dime-store teacup and every melancholy Pierrot on a piece of badly done embroidery is a sort of salute to Watteau, just as the actors Leslie Howard and Marion Davies were remembering him, whether they knew his name or not, when they dressed up as Harlequin and Pierrette for a California costume party, and just as Verlaine's cycle of poems *Fêtes galantes* and Cézanne's and Picasso's paintings of Harlequins and Pierrots are meditations on his art. Fashionable women in the late nineteenth century dressed à la Watteau and had their portraits painted in Watteau poses, and Jean-Louis Barrault's performance as Pierrot in Marcel Carné's great movie, *Children of Paradise*, owes its essential spirit to Watteau's *Gilles*. Of course many elements in Watteau's art predate Watteau. The Harlequin and Pierrot had been the core of the commedia dell'arte for centuries, already the subject of one sublime seventeenth-century artist, Callot. And the lovers in the gardens went

back at least to the Gardens of Love in secular medieval art, and had been shaped by Giorgione in Venice two hundred years before Watteau came to Paris. Watteau draws all this together: the quality of mingled insouciance and seriousness; the "Oh, it's nothing" that is another way of saying "Of course, it's everything"; the costumes that would inspire Cézanne's experiments in an austere modern style even as they supplied the kitsch imagery for countless knickknacks.

Diving deep into the art and the life of this great painter involves pushing through corridors into unknown rooms, opening shutters to reveal unexpected vistas, discovering trapdoors that lead to secret spaces. Let me give a few examples. I had not known that, as a young man, Samuel Beckett wrote excitedly about Watteau's work in letters to his great friend Thomas MacGreevy, and the letters turn out to be as revealing about Beckett as they are about Watteau. I found myself looking into Virgil's *Eclogues*, which represent if not the origins at least an early expression of the sense of pastoral not as a poetry of relaxation but as a poetry of anxiety and disquietude, a mood that is echoed, centuries later, in Watteau's darkening gardens. As I worked on these pages, I noticed people or situations around me—a solitary figure having breakfast in a coffee shop, an artist commenting on his work in his studio—that struck me as somehow Watteauesque. And I put them into this book. Friends offered their own reactions to Watteau, or gave me little nuggets of information, such as a letter written by Virginia Woolf in the late 1930s, in which there is talk of war and a

Watteau painting at the National Gallery is mentioned. Some of this had to be included, too. And I found myself thinking about my own early fascination with some of what I now realize are Watteau's themes, themes that were reflected, to give but one example, in the crude but wistful pastoral landscape that was painted on the wall of my grandparents' living room.

If there is some psychological impulse or disposition that colors all Watteau's work and his legend as well, it is perhaps the drive to transform powerful feelings—of love, friendship, lust, avidity, curiosity—into delectable artistic play. His ambition is not so much to tamp down these strong emotions as to work with them until they assume a poetic pattern. With Watteau, the cut of a dress or the turn of a head or the blush on a cheek has a psychological and narrative value that is simultaneously a formal value. He forces us to think about how we behave in our everyday lives, even as he pushes us to consider the way that an artist shapes those realities into the glorious make-believe that is a work of art. The unreality of his world is not a matter of escapism so much as it is a leap of the imagination, an effort to give a shape to our feelings, an effort to grapple with our raw, unedited emotions, which can all too easily prove overwhelming.

In order for us to get through the day and get along with other people, our emotions must at least to some degree be restrained. This is a basic fact of life. And with Watteau this restraint, this suppression of our inherent outrageousness, necessitates a spirit of fantasy, so that discipline and aban-

don turn out to be all mixed up in the uncanny atmosphere of his painterly realms. It's no wonder that, when I think of Watteau and his Harlequins and what they meant to Cézanne and Picasso, I find that I'm speculating not only on the theatrical comedy of the Harlequin and on Cézanne's love for his son but on the pure geometry of the diamond pattern as well. Watteau was a romantic and a realist and a formalist. He was an avatar of the stringencies of art-for-art's-sake who also invented an immortal cast of characters. And their avidities and follies are echoed in the behavior of the glamorous men and women in the screwball comedies of the 1930s—and, for that matter, in the easy conviviality of the men and women who nowadays gather in New York City bars in the early evening, after the day's work is done. In putting together all these variegated strands, I have found that it is not enough to stick to what I am sure I know, so that in certain instances, in writing about Cézanne's paintings of his son or about Watteau's close friends, I've allowed myself to tell some tales, to plunge into the romantic adventure of historical fiction.

A story that moves back and forth from Watteau to Picasso, from Venice to New York, from oil paint to the movies, must have some order. And it feels natural that these ruminations on the figure of Antoine Watteau have found their way into a book that takes the form of an alphabet. Alphabet books are characterized by a discursive order, an open-ended order, for although the procession of the letters is fixed, the entries offered under any given letter are infinitely variable. My thought is that, just as the alphabets

designed for children can reveal myriad aspects of the world, so this alphabet devoted to Watteau can suggest myriad aspects of a great artistic imagination, not only the man and his paintings and drawings but also the far-reaching implications of the world that he summoned up in his brief life, a world with its own savor, its own temperament, its own philosophical inclinations. And, like a children's alphabet, this one is meant to be read from end to end, as an unfolding panorama, a screen with twenty-six panels. This alphabet is Watteau's, but it also belongs to countless artists and writers who affected Watteau or were affected by him, which means that this alphabet is Giorgione's, Pater's, Cézanne's, Verlaine's, the Goncourt brothers'. And it is also, of course, my own.

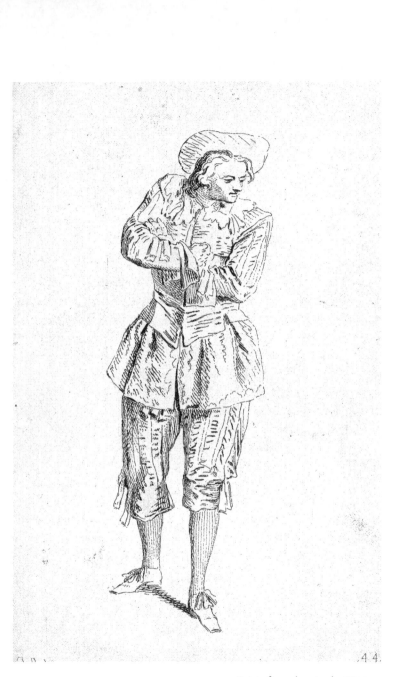

.44.

Print after a drawing by Watteau

A

Actors. For Watteau, life is a casting call, an audition, a rehearsal, a coaching session, an intermission, an opening-night party, a day spent in idleness after the play has shut down. Although Watteau's paintings are saturated with the life of the theater—with figures in theatrical costumes, with theatrical gestures, with richly decorated porticoes and loggias that suggest the contained world of the stage—the more I look at his paintings, the more forcibly it's brought to mind how few of his characters are actually onstage. The strictly delimited world of the stage is too readily comprehensible to really interest Watteau. An actor on a stage is a personality, a figure, and Watteau is fascinated, above all else, by the impossibility of ever being sure of who you are, at least for more than a very brief time. He is a master of in-between situations, less interested in life as a stage than in the preparations for going onstage, or how actors feel after they've made their exits. It's not the performer in performance so much as the mentality of the performer that fascinates him. He's obsessed with maskings and unmaskings, with grand gestures and whispered asides, with the moment of disarming honesty that is set in sharp contrast to the actor's generally armored personality. And he views such behavior—the histrionics and the feints, the approaches

and the withdrawals—not as characteristic of actors in particular but as typical of men and women in general.

Antony. At the time of his death in 1721 at the age of thirty-six, Watteau was a famous figure in Paris, with his share of devoted friends. The nuggets of reliable information about his life, however, are few and far between, so that every attempt to construct a biography from what scattered facts there are appears bound to fail. In accounts of Watteau's life, the artist himself is always at best caught in the process of disappearing from view, and it is the genius of Walter Pater's portrait of Watteau, "A Prince of Court Painters," that in assembling and readjusting some of the facts of the artist's life, this English essayist whose work is at once so luxuriant and so severe, constructs a fable about Watteau that is truer to what we feel when we're looking at his paintings and drawings than a more straightforward account could possibly be. Published in 1885 in *Macmillan's Magazine* and later included in the collection *Imaginary Portraits*, Pater's essay is a masterpiece of oblique storytelling. By relating the triumphs of Watteau's Parisian career from the vantage point of a childhood friend, a young woman who remains in what amounts to the backstage or offstage world of Watteau's hometown of Valenciennes in northeastern France, Pater imagines Watteau himself as the archetypal in-between figure. For Marie-Marguerite, the narrator of the story, this man whom she knows as Antony and with whom she has been in love since they were chil-

dren appears to be at home neither in the Valenciennes that he left to make his fortune and to which he occasionally returns nor in the glittery Parisian world that Marie-Marguerite can barely comprehend.

Pater's portrait, subtitled "Extracts from an Old French Journal," is a craftily constructed story, and not the least of the craft has to do with the fact that Pater's fictional journal keeper was also a real person whose surname happened to be Pater. Marie-Marguerite was the daughter of the Valenciennes sculptor Antoine Pater, who was a friend of Watteau's. Marie-Marguerite, in Walter Pater's telling, is watchful, discriminating, gently sentimental, fiercely insightful, a bit of a goody-goody, a bit of a priss. She is far too passionate and intelligent to be satisfied with the quiet life of Valenciennes, and as if in compensation, she has developed an almost frightening sensitivity to the moods of others, a sensitivity that mixes acute intuition with a certain degree of delusion, for to her the Parisian women who fascinate Watteau cannot be anything but poetic nincompoops. Marie-Marguerite is, of course, mostly an invention of Pater's, but her brother, Jean-Baptiste, was indeed a student and an important follower of Watteau's. There is no question that Walter Pater savored the thought that he was writing the journal of another Pater, who was in turn writing the story of Watteau's life, for it is reported that when the essayist was asked if he was related to Marie-Marguerite's brother, the painter Jean-Baptiste, he said, "I think so; I believe so; I always say so." Thus while Marie-Marguerite longs to love Watteau, Pater imagines himself as a part of

the eighteenth-century Pater family that actually knew Watteau. Pater's "A Prince of Court Painters" is something of a Chinese box construction, with Pater's late-nineteenth-century essay, a triumph of fin de siècle delicacy, enclosing the fictional journal of a heartbroken young woman, which in turn encloses the life of Watteau.

The extraordinary arc of Watteau's life, from his beginnings in Valenciennes to his death from tuberculosis near Paris in 1721, is told in a series of journal entries. Marie-Marguerite's unrequited love for Watteau has given her the ability, or so she believes, to understand him better than anybody else. And the Watteau about whom she dreams is very much the figure that we know from a portrait drawn by another eighteenth-century painter, François Boucher. The tilt of Watteau's head and the quick, glancing eyes give him the look of a man who thinks of himself as handsome and alluring in spite of the rather awkward way that his features fit in his large, somewhat fleshy face. Although there is dark poetry in his enormous eyes and aristocratic aggression in his long, sharp nose, there's also a dose of middle-class matter-of-factness in this man who appears small, almost childlike, with his large head set on narrow shoulders. His long, curly hair flows straight into the furry edges of his coat, and the coat in turn leads us toward his hands, so animated as to seem nervous, the left one resting on a portfolio, the right one holding a stylus that contains the colored chalk with which he did his innumerable drawings.

Marie-Marguerite imagines that Watteau has remained the self-contained adolescent she knew, and she consoles

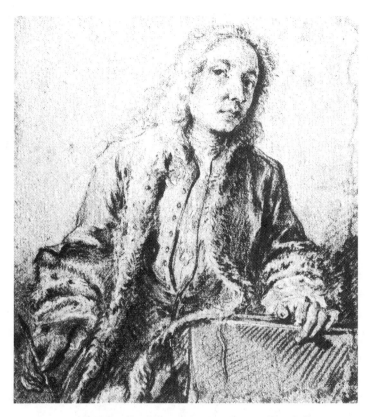

Drawing of Watteau by François Boucher (chalk on paper)

herself in her disappointment at his lack of attentiveness by convincing herself that he can get along with nobody. When her brother, who has gone to study with Watteau in Paris, is ultimately turned out and returns to Valenciennes "with bitter tears in his eyes;—dismissed!" she cannot help feeling consoled. "Jean-Baptiste!" she writes in her journal, "he too, rejected by Antony! It makes our friendship and fraternal sympathy closer." A few months earlier, on one of

his rare returns to Valenciennes, Watteau had begun a portrait of Marie-Marguerite. But three years later the portrait is still not finished—"my own poor likeness, begun so long ago, still remains unfinished on the easel." She justifies this to herself by considering that "it is pleasanter to him to sketch and plan than to paint and finish." Then she is crushed when it turns out that he has finished a portrait of another woman, the celebrated Venetian artist Rosalba Carriera. "She holds a lapful of white roses with her two hands," Marie-Marguerite writes, going on to observe that this painting "will be engraved, to circulate and perpetuate it the better." Watteau's portrait of this woman whom Marie-Marguerite somehow regards as a rival—a portrait that has been finished and will be engraved—is a terrible blow, so that Marie-Marguerite turns ever more obsessively to her journal, which at least, as she puts it, "affords an escape for vain regrets, angers, impatience."

What Marie-Marguerite views as Watteau's rejection of her may well be something closer to indifference, but whatever his thoughts are about her, she comes to believe that something in the style of the work with which he has made his great reputation in Paris is "at variance, methinks, with his own singular gravity and even sadness of mien and mind." Watteau, according to Marie-Marguerite, "seems, after all, not greatly to value that dainty world he is now privileged to enter." "He hasn't yet put off, in spite of all his late intercourse with the great world, his distant and preoccupied manner—a manner, it is true, the same to every one." She consoles herself for his lack of interest in her by

imagining that "it would have been better for him—he would have enjoyed a purer and more real happiness—had he remained here, obscure; as it might have been better for me!" It's as if she sees her own whimpering disappointment reflected in the equivocations of his enchanted figures. And, indeed, her neurotic infatuation with his aloofness goes back to the first years when she knew him, for when she wrote of his drawings in a journal entry in 1701, he was already fully formed, at least so she believed. She had seen him at the time of a fair, "hoisted into one of those empty niches of the old Hôtel de Ville, sketching the scene to the life, but with a kind of grace—a marvelous tact of omission, as my father pointed out to us, in dealing with the vulgar reality seen from one's own window." He had "made trite old Harlequin, Clown, and Columbine seem like people in some fairyland." That was his fascination, but it was a confounding fascination, because Marie-Marguerite, despite all her refinements, was part of the vulgar reality of Valenciennes.

This bright, good, pious girl wants Antony to be like her. The day after he's ended one of his visits to Valenciennes, Marie-Marguerite is at early mass; she watches a bird that has flown into the church and can't find a way out, and that bird suggests to her her own thwarted feelings. "The bird, taken captive by the ill-luck of a moment, re-tracing its issueless circles till it expires within the close vaulting of that real stone church:—human life may be like that bird too!" Much later, at the news of Watteau's death, she finds some consolation in the thought that in his last

days "he had been at work on a crucifix for the good curé of Nogent, liking little the crude one he possessed. He died with the sentiments of religion." This little story about the crucifix—which, by the way, is true—confirms for Marie-Marguerite what she had suspected earlier, when, looking at the panels of the *Four Seasons* that Watteau designed for her family's house, she'd reflected on "the purity of the room he has re-fashioned for us—a sort of *moral* purity; yet, in the *forms* and *colors* of things." For this sweet but tough provincial girl, Watteau is a paradoxical saint, and there is surely something of Christian piety in her remark—in what are the last words of her journal—that he was always "a seeker after something in the world that is there in no satisfying measure, or not at all." Although for Marie-Marguerite that something is religion, the fact is that as the closing sentence of Walter Pater's story has been read since it first appeared, that something is the religion of art. But surely Pater wants the doubleness of possibilities. "Something or something else—only give us some sort of meaning," so Walter Pater is quietly pleading through the voice of this virginal woman.

Art-for-Art's-Sake. The moderns dreamed of liberating beauty from the obligations of meaning, they conceived of beauty not as an idea or an ideal but as an irreducible sensation, an unforgettable kiss, a distillation of apprehensions and traditions and drives and desires and avidities, at once inevitable and serendipitous.

B

Backs. Consider a person's back, a woman's or a man's, whichever interests you more. The back is both carapace and core. The back is a volte-face face, a second face without the easy familiarity of the face, a face that denies the understanding of a person that is centered on the eyes and the mouth. And this denial can be a fascination, a relief, an invitation in its own right. Instead of the eyes and the mouth, there is this monolithic form, this wall of flesh, soft or muscled or softly muscled, dense or delicate, straight or bent, all of which can, in its own way, suggest the essence of a person's being. This is a face with its own kind of bilateral symmetry: the angled, mirrored shoulder blades; the muscles stretched over the rib cage; the deep, long cleft of the spine, full of coursing energies, descending from the head, animating the arms, the hands, the legs, the feet, and returning sense and sensation to the head.

However you look at it, the back has an extraordinary psychological power, a power that can be wonderful or disquieting or some combination of the two. Think of the back of a person you love. Or the back of a person you know very well. Or you may remember—vividly—the back of a person you hardly know at all. Consider the beauty or power or particular character of this back. Consider the

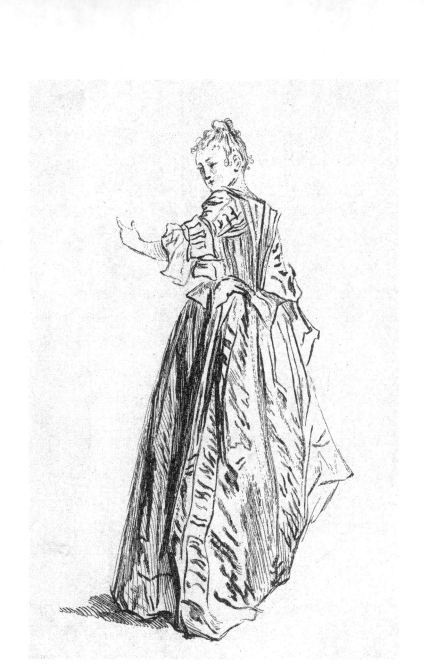

Print after a drawing by Watteau

emotions it inspires. You may be waiting for or wishing for this person to turn around so you can see more. Or you may have been through everything with this person and never want to see that face again. Or you may know that the turning away is only an interlude and that you will soon be happily face-to-face once more. Anybody who has experienced even one of these emotions, and the truth is that most of us have experienced all of them, can see that the back view is inviting, off-putting, seductive, mysterious, and many other things besides. Consider the phrase *turning your back*. This suggests a snub or an insult, if not outright rejection or total abandonment. And then there is backstabbing, an ultimate betrayal. But if somebody whose back is turned away begins to turn toward you, you may feel that you're at the beginning of an adventure. The back can suggest avoidance, resistance, hostility, withdrawal ("Getting your back up." "Backing away."). But the back can also suggest inwardness, reticence, seduction, fascination ("Who's the woman with her back to us?").

Of course Watteau had a special feeling for the back—a passion for it, you might say. Think of his paintings, and you're immediately thinking about a back: of the woman who stands on the lawn in the late afternoon, looking out at the vast garden where the young women and their admirers are winding down the day's amusements; of the pairs of lovers who face each other or approach each other or avoid each other in such a way that you're always seeing one of them from the back. I believe that Watteau's sensitivity to these back views had a great deal to do with his familiarity

with actors and dancers and musicians, for their work always depends on a feeling for the entirety of the body, not just the hands and the face but the back, chest, arms, legs, pelvis, thighs. The great performers act with their backs as well as with their faces. For Watteau, as much as for an actor or a choreographer, studying the back was not merely an ordinary daily activity, it was also the fabric of his working life, for as he drew the figure, which he did constantly, gathering together the sketches that would then flow into his paintings, he was always contemplating the back of the model. The model was regarded in much the same way that the choreographer or theater director regarded the dancer or the actor, as a totality—an expressive whole.

When Watteau and his friends got together, whether in Parisian apartments or country parks, everybody sat where they liked and talked with whomever they liked and let their hands wander however they pleased. And the informality of these lives, the freedom of these social gatherings, so far from the rigors of court life, found one of its emblems in the back. The eroticism of the back view was not lost on Watteau, not for a moment. In his *Judgment of Paris*, we judge Venus from behind. And of the few other Watteau paintings of nudes that have come down to us, one is of a woman reclining, turning to look at her own behind. That painting relates to a theme in his drawings and in prints after lost drawings, where enemas are sometimes being administered, an operation with obvious erotic implications. Not only in Watteau's work but also in pornographic prints and commedia dell'arte stunts of the period, a young man can be

seen carrying the clyster, an instrument as large as a shotgun. Let us also not forget that love went on in back rooms, behind the scenes, nor does it matter that most of the figures in Watteau's paintings, including all the ones who may be on the verge of retreating into those back rooms and shadowy, tree-lined alleys, are fully clothed. There is a silken nakedness about the clothing in Watteau, about the cut of the clothes, with the close-fitting waists on both women's dresses and men's coats emphasizing the great V-shape of the back, set in the pelvis, supporting the shoulders and the head.

For Watteau the back is at once an emblem of pure physicality and an emblem of pure spirit. The back is as provocative, as subtle, as mysterious as the face—but a face that is about-face, faceless in some sense. The back is a mask that is no mask at all, more perfectly fitted, more frustrating, and more revealing than the mask that Harlequin holds up to shield his mischievous eyes.

Beardsley. In *The Death of Pierrot*, Aubrey Beardsley's life-giving restlessness was muffled by an unconquerable melancholy. The year was 1896 and Beardsley, although in his early twenties, knew that he did not have long to live. He would die in March 1898, succumbing to the tuberculosis that had first afflicted him as a child. His entire creative life, all five or so years, was lived in the face of death in the dying years of the nineteenth century, lived with a bravery and a toughness that had little to do with the general image

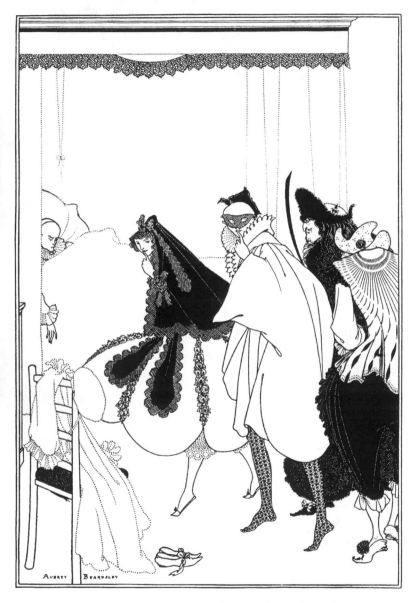

Aubrey Beardsley, *The Death of Pierrot*, 1896

of Beardsley as a languid aesthete. To be so sick and yet so industrious; to be so conscious of the end and of all he wanted to say before he got to the end; to be aware not only of his responsibility to his own imagination but also of his responsibility to his family, to a mother and a sister—this obviously required extraordinary courage. And perhaps it was inevitable that Beardsley's courage was braced by a certain irony, a toughly comic attitude toward his own apparently hopeless situation.

In *The Death of Pierrot*, the bloody extravagant march of death, the atmosphere of Wagner's *Götterdämmerung* or Tchaikovsky's *Symphonie pathétique*, is reduced to the tinkling of a harpsichord in a Scarlatti sonata in a far-off room—to a drawing that suggests a last, muffled laugh. The clown in the white costume, the Pierrot with the gentle spirit of a dreamer in a painting by Watteau, actually makes a number of memorable appearances in Beardsley's work. In one drawing we see Pierrot in a bibliophile's heaven, halfway up the library stairs, a smile playing across his face, a book in one hand, his other arm reaching for a second volume. Like the dying Pierrot, the bookish Pierrot is Beardsley himself—the dreamer, the imaginer, the creative spirit. But in this incarnation he is still in his ebullient phase, working his way through the great volumes in some baronial library, immersing himself in the Japanese and medieval and Renaissance images that will inspire his own astonishing inventions. And having seen him in all his scholarly glory makes it all the more heartbreaking to turn to *The Death of Pierrot*, where the bookish dreams are gone

and his work, no matter how much he has accomplished, must be left undone. Pierrot has taken to his bed. The play—the play that is Pierrot's life—is complete.

Pierrot's bedroom is indicated in the most circumspect manner. We see the bed, with draperies that are rather severe save for a bit of lace, and a simple chair, on which Pierrot has dropped some clothes. Sunk in sleep, perhaps (who knows?) already dead, his face pinched and severe, he has become a wizened mask. And in this sad state, Pierrot is visited by four revelers. One carries a sword, another wears a mantilla. They are dressed as if they've come straight from some party or performance, or perhaps they are headed there. Two of the visitors, in acknowledgment of Pierrot's sorry state, hold a finger to their lips. Don't disturb the artist, they tell the others, not because he's at work but because death is at the door. An early biographer, Haldane Macfall, who had actually known Beardsley, wrote that *The Death of Pierrot* "is wonderful for the hush a-tiptoe of its stealthy-footed movement." The tentative steps of the deathbed visitors send a chill through this drawing that is at once so incisive and so elusive. Beardsley is imagining his own death, he is Pierrot contemplating the death of Pierrot, plunging into a twilight zone somewhere between creativity and oblivion. The thinness of his tragically elegant lines suggests the breaking off of everything.

Beginnings. So much begins with intense yet fragmentary experiences. At the start of a friendship or a love affair

there may be some acute recognition, some striking sliver of experience, although initially it's impossible to know where this will go, if indeed it will go anywhere. You meet someone, you have a conversation, an argument, some sort of physical interaction, and frequently it's just that—an isolated event. Years later, you may look back on such encounters, and it can be odd how some that were so full of promise led to very little, while others, far more ambiguous at the time, precipitated much else, perhaps too much. So it's no wonder that even as you are in the midst of these initial experiences, and more so after they're over, the question that hovers is whether whatever has happened can grow, whether this sharply defined early encounter can find a place amid all your other relationships and needs and obligations. For the time being, that initial encounter is a vivid image in a larger landscape that looks misty, elusive, frustratingly faint. This is one of Watteau's essential subjects, both the intensity of the immediate experience and the frustrations or difficulties or excitements of seeing where it will go. Watteau begins with the vivacity of drawings, each a sharply observed encounter, an intense sliver of experience. These slivers of experience are then gathered together, related to one another in a painting or a group of paintings, although the relationships among the parts are frequently left indeterminate, even in Watteau's most beautifully finished canvases, where there is invariably an element of wavering, quivering fluidity, as if to say, "It is all beginnings, there is nothing but beginnings."

Print after a design by Watteau

C

Capriccio. Not the construction but the unfolding or unfurling of a world, a mysterious movement, delicately meandering, full of S-curves and zigzags, forever decentering, snaking and circling, leaping forward in great arcs and pulling back in tight curls—this is the impulse behind Watteau's art, whether in the twisted fingers of a young lover in a drawing or in the pileup of pleasure seekers in one of his grandest oil paintings.

This impulse, this particular wiring in the circuitry of the imagination, has a long history in the West, and has over the centuries been associated with a curious cluster of words, including *arabesque, capriccio,* and *grotesque.* They are words with mutable, equivocal meanings, always pointing to the marginal rather than the mainstream, the stumbled upon rather than the meticulously planned, fantasy rather than fact. The grotesque, which suggests the odd and the bizarre as much as the fearful and disquieting, can be traced back to the fantastically decorated grottoes of ancient Roman villas. The capriccio takes us into the psychological dimensions of these glorious meanderings. This word, nowadays associated with musical or visual play, whether Paganini's violin solos or Guardi's oil paintings, also evokes the capricious behavior of certain individuals,

those who—according to Cesare Ripa's description of an allegorical figure named Capriccio in his *Iconologia* (Rome, 1593)—"base their actions on ideas that vary from what people normally take for granted." And arabesque is of course Arab-style, growing from seeds that may have been carried along the Silk Road from Asia. Those seeds flowered in the churches and palaces of Byzantium, in the S-curves and figure eights of entwined animal motifs spreading as far west as Ireland and north into the plains of Russia, in the intoxicating patterns of Persian carpets and miniature paintings and tiled mosques—each orderly arabesque suggesting the afterimage of a spontaneous gesture, of that first curling line, of that first joining of squares or triangles into rhythmic movement. The arabesque, the capriccio, and the grotesque return time and again in the history of art, in the curious figures and narratives on the edges of medieval manuscripts, the startlingly juxtaposed images in Leonardo's notebooks, the confoundingly overlapped borders of the Mannerist frescoes at Fontainebleau, and the densely phantasmagorical seventeenth-century theatrical designs of Jean Berain.

And in Paris in the first decade of the eighteenth century, the spirit of all those meanderers and doodlers and dreamers who had worked in ancient Rome and medieval Europe and all through the Renaissance was reborn yet again on the paneled walls and stuccoed ceilings of elegant drawing rooms. Watteau, working for a time with the painter Claude Audran III, embraced this decorative tradition, designing and executing the light, fantastic traceries that gave these

drawing rooms their playful elegance. So imagine that you are in the drawing room of a *hôtel particulier,* one that Watteau has painted. Look over there, across the room, at the airy suggestion of a garden that has been painted, or perhaps calligraphed is a better word, on a pale blue panel. A monkey walks a tightrope, and just beneath him another monkey, playing a tambourine, is suspended on a platform in midair, a platform that suggests young sprouting branches. And then, beneath that, a couple are dancing, not exactly together, but the woman to the left, seen from the back, apparently responding to the man, who raises his arms and kicks up a foot. They are figures with a certain weight to them, a weight that surely cannot be supported by the narrow wedge of earth on which they stand, a wedge held aloft by nothing, a magician's illusion, decorated with floral swags, not so much modeled in paint as penned in paint, as if the brushstrokes were thoughts inscribed on the paneling. But you cannot linger here any longer, for somebody has just drawn your attention to the fan held by a woman seated elsewhere in the room, a fan painted by Watteau, or so it is said, on which two sprigs of flowers become the shoulders and heads of a man and a woman, a curious human canopy beneath which a coquette and a Pierrot exchange seductive glances.

Watteau is recklessly capricious, a weaver of arabesques who embraces the grotesque, not in the sense of gothic horrors but in the sense of curious divagations and transmutations. And if there is a characteristic figure in his art, it suggests the Capriccio of Ripa's *Iconologia,* "a youth dressed

in a garb of various colors. Let him wear a hat colored like his garment and topped with various feathers." This, come to think of it, is nearly a description of Mezzetin. Watteau's paintings are full of echoes of Ripa's sartorial prescription. And it is in the nature of the painter's capriciousness that, although he is very precise about the handling of certain costumes, he leaves us with the impression that his young men and women have ransacked the costume closet of the commedia dell'arte in order to satisfy some inherently unstable sense of self. Watteau wants not only his figures but also entire compositions to grow organically, with a curve turning into a figure, that figure eliciting another figure, and that doubling perhaps generating an idea of rhythm or pattern—and eventually a space filling with forms through a process that begins in disorder but enforces its own kind of order. This is freedom reincarnated as a compositional principle, an idea about the naturalness of stylistic evolution, of style not as being but as becoming. And for Watteau—who always worked as if he never knew what was coming next, filling sheets with helter-skelter studies of heads and hands and entire figures and then combining and recombining those sketches into increasingly complex structures—this compositional principle took on the weight not so much of an artistic principle, although it was surely that, but of a philosophic principle.

Cézanne. Cézanne was sitting at a plain wooden table, examining some drawings that he had done in the past few

weeks. The year was 1888, and he had been back in Paris for a time, living in an apartment on the Île Saint-Louis, one of the older parts of the city, working in a studio not far away on the Left Bank. The drawings were scattered across the table in the studio, studies in pencil of an elongated young man dressed in the form-fitting costume of a Harlequin, the diamond pattern drawn in soft strokes, the geometry suggested, but only casually. Looking at the drawings, moving them around, Cézanne was trying to figure out if there was something here, a telling fragment from which he might tease some grand design, a glimpse or vignette that he could develop into a painting. He was fascinated by a quality in these drawings for which his son, Paul, had been modeling, putting on the Harlequin suit that Cézanne had bought— oh, he couldn't remember where he'd bought that suit, although he did know that it was around the same time that he had picked up the big, floppy white Pierrot costume. What he also remembered was that he had thought he might use these two outfits in some boldly dramatic narrative painting, a riotous commedia dell'arte bacchanal, a theatrical extravaganza packed with reminiscences of the Venetian banquets that Veronese loved to paint. But he was now middle-aged, and the red-hot themes that he had once embraced, the feverish, scandalous scenes that had interested him, seemed not so much foolish as quite simply impossible, or maybe implausible was more like it.

So for a long time, for years in fact, these two commedia dell'arte costumes, Harlequin and Pierrot, had been hanging in the studio, gathering dust along with some old bot-

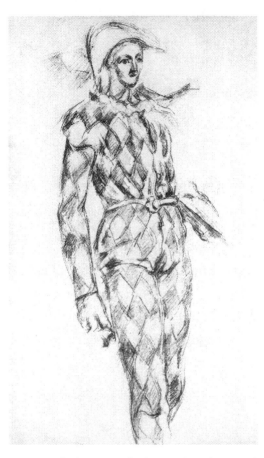

Paul Cézanne, *Harlequin*, 1888 (pencil on paper)

tles, some plaster casts, a few baskets, a skull. This was how it was in Cézanne's studios, this gradual accretion of objects, piling up in the corners. He found it difficult to paint anything until it had become absolutely familiar, but of course by now these costumes were utterly familiar, they felt as ordinary as the apples and bottles that he used all the

time in his still lifes. And when you came right down to it, there was nothing particularly out of the ordinary about these outfits, which just about anybody might have worn to a costume ball, that is anybody who went in for such entertainments. Harlequin and Pierrot were ubiquitous in the theaters and music halls, those places that Cézanne had frequented years earlier, when he'd first come to Paris. And even this man who by now seemed so indifferent to the world around him, who was so immersed in his own thoughts that he barely noticed his surroundings as he went back and forth from his studio to his home, even he would have registered the impressions of Harlequin and Pierrot that were to be found on cheap prints and posters and advertising cards—these amusing kitsch characters, these most hackneyed of theatrical figures, these reminders of the immemorial mingling of art and comedy and illusion.

Why Cézanne had thought of asking Paul to put on the Harlequin costume the artist couldn't quite say. And yet it really should not have been that hard to understand. For hadn't Cézanne, not long ago, as he looked at his teenage son across the dinner table, exclaimed in a moment of almost fearfully strong affection, "Whatever mischief you may get into, I shall never forget that I am your father." And why, after making that remark, wouldn't he have wanted to dress his son in the costume of Harlequin, the hot-blooded, mischievous devil of the commedia dell'arte? As Cézanne worked on these drawings, he found himself elongating his son's proportions, as the artists of the late Renaissance had done when they painted a young

prince. After all, Paul was Cézanne's young, ripe, adolescent prince. And as Cézanne worked on these studies of the boy-Harlequin, extending his legs and angling his torso, he transformed him into a fleet-footed, secular Mercury. True, these allusions to Renaissance princes and Greek mythology were barely intimated, they were under the surface, but surely Cézanne was feeling that the red of the Harlequin outfit had some intuitively symbolic weight, some quality of the sanguine, of blood ties, of hot-blooded youth, of pure health, the health that the middle-aged artist would never see again.

In the days since he'd looked over the drawings, Cézanne had remained uncertain as to how he would proceed. Walking back to his apartment on the Île Saint-Louis, looking at Paris in the fading light of a warm autumn evening, he thought of all the dance halls and artists' balls and circuses and theaters that had fascinated him when he'd first come to the city, and he yearned to paint something that would memorialize that world, that would convey its afterglow. He had started a painting of Paul in the Harlequin costume, but there was something more that he wanted to do with this idea, some more expansive story that he wanted to tell. And then, one evening at home, he was watching as Paul sat talking with his great friend, Louis Guillaume, and Cézanne found himself fascinated by their shy yet easy closeness, the closeness of two sweet, bright-eyed boys, and it occurred to him that maybe, if Louis would wear the Pierrot costume, he could paint Paul and Louis together, as Harlequin and Pierrot.

Cézanne didn't ask Louis just then if he would model, he thought it was only fair to ask Paul first. The next day, when they talked about it, Paul seemed to like the idea of his friend being in his father's studio, and he agreed to speak to Louis. So Louis came to the studio, and Cézanne did a few drawings of him in the billowy Pierrot suit, the shy boy looking almost lost in the great creases and folds of the costume. At that point, Cézanne was beginning to get excited by the thought of this painting that he was going to call *Mardi Gras*. He was feeling that the subject had a power that was at once melancholy and romantic, and that by painting these two adolescents, painting them as he was turning fifty, he might capture not only the optimism of young people who were setting out into the world of love and illusions but also the evening clarity of a man who had left behind, or at least hoped to leave behind, those excitements and torments.

When a canvas had been stretched, Cézanne invited the boys to come to the studio together, and as they got dressed he rearranged the heavy draperies that he'd tacked to the wall where they were going to stand. He wanted the draperies, with their dark, leafy pattern, to feel informal, but also to suggest the enclosed world of a proscenium stage. And as he worked with the boys to see where exactly they should stand, asking them to move an inch or two this way or that, Cézanne found that the composition was turning into a sort of procession, with Paul leading the way. Cézanne wasn't thinking about illustrating some particular point in a theatrical performance. As he asked the boys to

Paul Cézanne, *Pierrot*, 1888 (pencil on paper)

shift their positions ever so slightly, he was at one moment imagining them backstage, imagining them preparing to go onstage. And a moment later, he was imagining them at the conclusion of a performance, coming before the curtain, taking their bows. What interested Cézanne was the play of curtains and costumes and these two flesh-and-blood boys.

Paul was turning out to be the leader, voluptuous but also haughty, inscrutable. And behind him was Louis, the diffident, poetic clown, bending, nearly bowing behind Paul's impressive, knife-blade profile. Perhaps it was inevitable that Cézanne was going to focus on his adored son. But it wasn't that simple. As he worked, sometimes with the

two of them posing together, sometimes with only one of the boys in the studio, Cézanne let his mind drift to his own memories of youthful friendships, especially the great camaraderie that he and his old friend Zola had once shared, during long, lazy afternoons in the hot, golden countryside around Aix-en-Provence. It was difficult for Cézanne to think about those afternoons with any equanimity, not after Zola had embarrassed him so deeply with the publication of *The Masterpiece*, his novel about the artist's life in which the wildly deranged figure of the painter had seemed to everybody to be an only slightly exaggerated version of Cézanne. But as he watched the two boys in his studio, what came back to Cézanne were the pleasures of youth, reflected in Paul's brazen glance, eyebrows raised, almost winking at his father, and in Louis's more removed expression, his eyes two dark pools.

Louis must have felt far less at home in the studio than Paul, and it was characteristic of Cézanne's delicate feelings that he did not insist on confronting Louis directly, that he allowed him to hide a little, to stand a step or two behind Paul's emboldened figure. Perhaps Louis was becoming a stand-in for Cézanne himself, the one who stood aside, who watched, who waited, and who was fascinated by Paul's Harlequin costume, so form-fitting, so slyly sexy, with the baton held under his arm suggesting a toy soldier on parade. At moments, Cézanne didn't know quite what he was painting. Was it a double portrait? Was it a painting of boys? Or of young men? Or was it a painting of two fictional characters, Harlequin and Pierrot, the mischief

makers of the commedia dell'arte, whom the poets of the nineteenth century had by now wreathed in an atmosphere of moonbeams and nostalgia?

On different days, Cézanne had the feeling that he was painting different paintings. Sometimes he felt as if Paul and Louis were stepping onto the stage of a theater, which was also the stage of life. But at other times, as he watched the boys get into their costumes, laughing at their own images in a mirror in the studio, he had the opposite feeling, namely that these adolescents were dressing up in costumes that sent them straight back to childhood. Cézanne didn't feel as if he were painting Paul and Louis so much as if he were painting a whole kaleidoscope of identities: the child, the young man, the Harlequin, the Pierrot. And Cézanne loved the fact that Paul and Louis were wearing their costumes gladly and eagerly but also with a certain casualness. As he worked out the patterning of the black and red diamonds on Paul's chest and the great white ruff around Louis's neck—and this was slow, methodical labor—Cézanne was aware of how easily the boys sloughed off these costumes. As soon as a modeling session was over, they would be back on the Parisian streets, talking heatedly, intimately, as friends like to do. And Cézanne realized that, like so many adolescents, they imagined they were going to be able to slough off all the identities that life had to offer— they were still young enough to be dreamers.

Cézanne, working at his easel, his penetrating gaze moving from the paints on his palette to the delicate, youthful faces and then to the canvas, where many areas were still

bare, admired their adolescent optimism; he reveled in it. He loved the ease with which the two boys struck up a relationship with Harlequin and Pierrot, a relationship that was experimental, provisional, show-offishly nonchalant. Cézanne, who refused to be show-offish, who refused to be nonchalant, was observing all that boyish abandon, and recording it with a touching, admiring, adoring care. Indeed, he could not leave the painting alone, and so as he worked the surface became thicker, darker, incrusted with pigment, a surface that veiled as much as it revealed. But late one afternoon, after Paul had taken off his costume and hung it on the hook and gone off to run some errands, Cézanne sat alone, looking at the nearly finished canvas, and it was as if all the uncertainties—Paul or Harlequin? Backstage or onstage? Children growing up or adolescents playing at being children?—had coalesced into a single, monumental uncertainty, a strangely somber harlequinade, a painting at once foolishly fantastical and unashamedly, even heartbreakingly, literal.

Classicism. *Classic, classical, classicism:* these words suggest conflicting ideas and ideals, styles and epiphanies, neos and revivals, and it is no insult to such a complex array of values and apprehensions to say that any exploration of classicism turns into an excursion in a house of mirrors. Classicism equals wholeness, completeness, and stability, but who is to say what is whole, complete, stable? With Picasso, Gris, and Derain, the commedia dell'arte was pre-

sented as a classical idea, a play of ancient, archetypal figures, but this was a classical idea that was deeply indebted to Watteau, whose work, if indeed it is classical, is classical not in style but in spirit. However much Watteau may have yearned for wholeness, completeness, stability, he was equally eager to push them away. His Harlequins and Pierrots are not essences, they are not quintessential types—they are not Everyman. With Watteau, classical wholeness is not something to be achieved but something to be aware of, an enduring hope or promise, a prize to be pursued but not necessarily to be captured. At which point classicism, for all intents and purposes, has become romantic.

Color. I had been wondering about Watteau's color, wondering how to describe the changeableness of his color, how to explain his refusal to treat a painting as a single, seamless orchestration of color. And while I was thinking about all of this, I went for a walk here in upstate New York. And almost immediately I began to understand what Watteau was after, for my attention was at one moment enveloped by the soft, gray-violet light of the dying afternoon, while at another moment I found that I was fascinated by some startling spot of local color, the green of a leaf, the red of a painted fence. Then I realized that there are painters who are inspired by this sort of experience, by the unsettledness of color, the disunity of color, even the bafflement of color. When writers criticize Watteau's color, when they say that he is a sublime draftsman but often an unsatisfactory

painter, it is because they have misread as uncertainty what is in fact his extraordinary grasp of this unsettledness, this disunity, this bafflement. Watteau's color stubbornly defies description. His color is unmoored, a ceaseless surprise that is often almost colorless, a physicality or palpability that is suggested without being fixed, a never-ending battle between local color and the color of light itself. His paintings can be highly colored and yet sometimes nearly monochromatic, raucous but with the subdued shimmer of slightly tarnished silver.

Commedia dell'arte. Of the commedia dell'arte—the theatrical entertainments, featuring Harlequin, Pierrot, Pulcinella, and many more, that originated in the city squares and marketplaces of Renaissance Italy—George Sand had this to say: "The commedia dell'arte is not only a study of the grotesque and facetious, but also a portrayal of real characters traced from remote antiquity down to the present day, in an uninterrupted tradition of fantastic humor which is in essence quite serious and, one might almost say, even sad, like every satire that lays bare the spiritual poverty of mankind."

Detail from a print after Watteau, *The Two Cousins*

D

Daydreams. Art is the necessity of the unnecessary, a daydream reshaped through the imperatives of the painter's rectangle of canvas. And the power of certain great paintings, no matter how much self-conscious craft the artist brings to the work, is the quality of a daydream, an orchestration of elements whose meaning remains ambiguous or contradictory. The fascination of such a painting is directly related to the fascination of daydreams, for we do not necessarily want to know what they mean so much as we want to linger over them, sink into the luxuriant satisfactions of such fantasies, although we can also be alarmed or even repelled by their power. In daydreams, meaning is never fixed. So it is not strange that Watteau, a painter who comes so close to mirroring their ambiguities, should inspire a great deal of scholarly disagreement, with some arguing that the mood of his work is essentially upbeat, playful, optimistic, while others see the mood as shadowy, melancholy, troubled. Daydreams, of course, can be all of these things at once. The man, the woman, the fountain, the statue, the pond, the ruined building, the grove of trees, the Harlequin, each of the elements can mean many different things, and Watteau struggles with the teeming possibilities.

The struggle cannot always have been easy, and there is some confirmation that Watteau found himself confounded by the force of his own imagination, at least if we accept the assertion of many scholars, that a painting called *The Artist's Dream* is by Watteau. It is a curious canvas, perhaps painted early in his career, perhaps later. The artist has set up his easel in a ruined structure in an overgrown park, a rustic shrine. But he is unable to paint. He has turned away from the easel, he is collapsing, his head flung back, his arms gesticulating wildly around his face. He must be despairing of the possibilities of painting, for he doesn't seem to know what to do with the vision that is now before him, suspended in the air, a rococo Parnassus, a gathering of figures, a sort of theater party, with Pierrot and Harlequin and cupids and one particularly lovely young woman, the painter's muse. The poor painter is beset by the power of this vision that is his very own vision, he fights it off as if it were a swarm of bees, he is at once stung by the daydream and stung by the difficulty of capturing it on canvas.

Deburau. Sitting at a café along the Promenade des Anglais in Nice one brilliant day in the spring of 1943 were an actor, a writer, and a movie director: Jean-Louis Barrault, Jacques Prévert, and Marcel Carné. They were tossing around ideas as they nursed their aperitifs, excited by the easy intellectual talk of good friends, glad to be together, happy to be sitting on the famous street with the wedding-cake fantasy architecture of the belle epoque

hotels at their backs and, spread before them, the tall, slender palm trees, the stretch of beach, and the sparkling Mediterranean. They were trying to decide on a movie project, always a complicated business, but all the more so now, with France controlled by the Nazis, as any proposal would have to be cleared with the fiercely demanding Vichy censors. So the trick was to find something exciting, consuming, important, but something that wouldn't raise flags with the officials. Period dramas had a particular attraction, for there was a lot of heartfelt feeling, a lot of immediate response to events, even a lot of social or political comment that could be masked if it were reframed in a distant time and place. Carné and Prévert had just finished *Les Visiteurs du soir,* a fable of fifteenth-century Europe, with a style derived from the courtly elegance of early Renaissance manuscript painting.

But what to do next? This was the question. Ideas were suggested and rejected, and then Barrault, his rapturous eyes set off by the sharp angles of his long face, began to talk about his fascination with Jean-Baptiste Deburau and Charles Deburau, the mimes, father and son, who had transformed the catch-as-catch-can Pierrot of the old commedia dell'arte into a scintillating presence at the Théâtre des Funambules in Paris. Jean-Baptiste Deburau had been the white clown in the 1830s and 1840s, when the audience was mostly made up of poor Parisians who were looking for an hour of hilarious, dirty comedy and loved the snarky, subversive character. But in thinking of the Funambules, Barrault was also thinking of the development, over a

period of years, of an increasingly Romantic vision of Pierrot—a vision that Charles would inherit from Jean-Baptiste—as an austere and lyrical figure, a figure out of Watteau. And as Barrault spoke to Carné and Prévert on that afternoon on the Promenade des Anglais, describing, almost acting out the moves of the Deburaus, father and son, the three men began to see the possibility of an encyclopedic study of theatrical Paris, with its street theater and its Shakespearean tragedies, its artists and its swindlers, its love affairs onstage and off.

A few days later, after Barrault had introduced Carné and Prévert to the photographs that Nadar had taken of Charles Deburau in the 1850s, everybody agreed that the movie had to be made. For Nadar's beautiful, sepia-toned images suggested the spiritual center of nineteenth-century Paris, with Pierrot, almost Asian in his austerity, moving like a ghostly magician through the perfervid Parisian climate. "My heart is like my face," Charles's father had written to George Sand, and what a face this is, a long white mask of a face, with exaggerated cheekbones, hyperanimated eyebrows, and a wide, thin, rubbery mouth—a face forever amused, bemused, sardonic. And so *Children of Paradise* was born, the children of paradise being both the poorest theatergoers, who took the seats in the highest balcony (known as "the gods"), and perhaps more generally the actors themselves, forever besotted by the paradise of the theater.

Filmed in the midst of World War II and first shown in Paris in March 1945, when the city was liberated but the war

was not yet completely over, *Children of Paradise* was greeted, both in France and beyond, as a reaffirmation of the grandeur of Paris, of Paris as the city of art and love and therefore of the human adventure in all its wondrous complexity. With its gorgeously detailed sets, its intricately panoramic crowd scenes, its interlocking love stories spread over a period of decades, this stupefyingly delicious spectacle is a potboiler, but a sublime potboiler. The astonishing opening scene of the Boulevard du Temple, packed with crowds and carriages and sideshow acts, is a stage set that combines a realistic sense of detail with an expressionist intensity. (The set designs were developed by Alexander Trauner, a Jew in hiding in Vichy France, whose dark, powerful ideas were then filtered through the work of another designer, Léon Barsacq, a man acceptable to the Vichy authorities.) The result is a hyperbolic truth that brings together every impression of nineteenth-century Paris that we recall from the novels of Balzac, Flaubert, Zola, and Proust.

The actors inhabit their roles as if they were born to play them. Carné once observed that "I've hardly ever been so pleased with the actors." The ragpicker, played by Pierre Renoir—actually a last-minute replacement for Robert Le Vigan, who was involved in pro-Nazi activities and fled France as the war was ending—is a down-at-the-heels Father Time, watching the world whirl by. Pierre Brasseur, as the actor Frédérick Lemaître, leaves an indelible impression of wild, happy ambition. His big smile and dark, bold eyes carry him straight from his first appearances, as the

absurdly overconfident young man trying to get a foot in the theater door, willing to take any job, willing to wear a lion's suit, to his later scenes, where he is the polished Shakespearean, master of the Parisian theater, preparing to go on as Othello. And at the core of the movie are the pair of lovers. Arletty, the French screen star, is Garance, the courtesan with the body of a goddess, the eyes of a sphinx, the self-possession of an empress. Arletty's face is the most beautiful oval in the world, the whitest marble carved until it suggests a perfect softness, a head of Venus. And Barrault, playing Jean-Baptiste Deburau—called Baptiste in the movie—is light, agile, a tender apparition.

I can still remember, as a teenager, sitting in a theater and watching Carné's movie. I was an uncomfortable teenager, never at ease, a sort of Pierrot, but then maybe all teenagers are. And there I was, in 1966 or thereabouts, devouring this allegorical banquet, minute by minute, all three and a quarter hours, until I began to feel that my very being was dissolving in the silvery images, as if I were going to vanish into the hotel rooms and dressing rooms of this movie that had been filmed in the South of France in the difficult days of 1944, some twenty years before I saw it. Thinking back on the first time I saw *Children of Paradise*, I realize that I was held not only by the movie's lush, resplendent, nineteenth-century romantic drama, this bohemian *Gone With the Wind*, but also by something else, a different kind of romanticism, something related to the years when the movie was made. I suppose the secret of all the great historical costume dramas is that they are double dramas, for

you are seeing a historical period, whether 1700 or 1900, through the vantage point of the time when the movie was filmed.

The men who created *Children of Paradise*, whether consciously or not, were reframing the hyperbolic emotions of the nineteenth century in the nightmarish chiaroscuro of wartime Europe. And by combining two temperaments—a nineteenth-century optimism and a modern pessimism—they defined a timeless tension in romanticism, a sense that we are both born into the world and borne away by the world, a tension between the pleasures of self-awareness and the fear of being dissolved in the group, in the crowds along the Boulevard du Temple, in the theatrical orgy of nineteenth-century Paris. *Children of Paradise* ends with the wild street theater of carnival time, with dozens upon dozens of Pierrots flooding the boulevard, surrounding, enveloping, almost smothering Deburau, the greatest Pierrot of all, who is now in his street clothes, his face a mask of agony, as Garance in her carriage disappears—from the Boulevard du Temple, from Paris, from his life.

With its duels and its villains, its two-bit thieves and its wealthy aristocrats, the movie has all the narrative complexities of the encyclopedic nineteenth-century novels, and yet Baptiste and Garance, although they are the protagonists of the unfolding drama, also stand slightly apart. In a movie where we never see the lovers undressed together, and indeed never see much physical passion, it is the simplicity of their beautiful faces, the nakedness of their looks, that registers their love. There is a sense in which Barrault,

Prévert, and Carné want to distinguish Baptiste and Garance from the strawberries-and-cream luxuriance of the movie, want to give their acting a minimalism that complicates the chocolate-box extravagance of *Children of Paradise*. At certain moments the faces of Baptiste and Garance are no longer nineteenth-century faces, no longer the Pierrot of the Funambules and the courtesan in her impossibly elegant dressing room, but twentieth-century faces, pure and simple. Barrault and Arletty, while absolutely the clown and the courtesan of romantic mythology, are simultaneously Existentialist emblems, he of pure feeling, she of pure erotic energy, neither capable of getting what they really want out of life.

Perhaps what gripped me when I first saw *Children of Paradise* was the sense of Barrault and Arletty as being at once part of the absurdly romantic story and utterly alienated from that story, at once enclosed in the cushioned daydream of the past and thrust into the hard-edged present. What I do know is that I wanted to lose myself in the twilight zone of their passion. How I wanted to be Barrault, to be the languid intellectual of the theater, at once absurd and compelling and in love, at once a figure in a fantastical drama and the hero of my own life in the present, a conquering hero in my very inability to conquer.

Diamonds. Angled, tilted, pointed, squeezed, exaggerated—the diamond shape has a humorous, tongue-in-cheek look. This is a square that's gone out of whack, with

two corners forced together and two pulled apart. No wonder the diamond shape, repeated, pulled taut over arms, legs, and torso to form Harlequin's costume, although altogether abstract, expresses his wit, his wildness, his spirit. This is fascinating to contemplate, the fact that geometry can evoke the comic spirit. And it is all the more interesting because there is an evolutionary process at work here, for Harlequin's costume did not begin this way but was initially decorated with randomly shaped scraps of colored cloth, which then evolved into a costume made of triangles of color, which finally came to be represented, more and more, as a costume composed of diamond shapes. It is as if that costume yearned for its own perfect form.

This is a formal adventure that can easily be illustrated. Imagine two equilateral triangles next to each other— △△; or two isosceles triangles— ⋀⋀; or two squares—☐☐; or two squares upended to make diamonds— ◇◇. They are all relatively sober, at least in comparison with two diamonds that are sharply angled, that are unequally angled— ◈. The tightening and the loosening of the corners spell exaggeration, hyperbole—comedy. No wonder the diamond pattern has been an emblem of campiness, wit, inebriation, high spirits. The immediate association of the diamond with the deck of cards is an element here as well, another instance of the diamond's fundamental affinity with the urge to play. Playing cards, like the figure of Harlequin, were probably born in Italy, and it is perhaps worth noting that Balanchine, who choreographed Stravinsky's *Jeu de Cartes*, also staged *Harlequinade*. It is as if the entire narra-

tive of Harlequin, his crazy doings, his wildness, could be distilled in the repetitions of a certain kind of pattern, a formalization of feeling, an abstraction of high jinks, high jinks as angles, hilarity created with a protractor and a few colors. It is this idea that may first have occurred to Cézanne as he painted his son in *Mardi Gras*. And in the Harlequins of Picasso and Gris, the diamond became the actual subject, an ultimate formalization of feeling, a distillation of feeling into the pinched-and-expanded, pushed-and-pulled character of this shape, this exaggerated square, this square turned into a sort of exclamation of itself. At the end of his life, though, Picasso, the creator of so many Harlequins, chose to confound the history of Harlequin's diamonds, returning in some colored drawings to the old patchwork costume, the suit made of randomly shaped, parti-colored elements. Picasso was rejecting the sophistication of the diamond in favor of Harlequin's beginnings, in favor of Harlequin's inchoate, improvisational, pre-geometric state.

E

Economy. Economy is always a guiding principle in the arts, even in the most elaborately articulated images, the wildest caprices, the fantastic altarpiece constructed of a variety of precious marbles and metals. I would make a distinction here between economy and restraint. Restraint involves a pulling back, a withholding of feeling. Economy in the arts is something closer to a maximizing of power, the most done with the least, so that there is always something in reserve, so that more can be done.

Watteau understood this. He might be said to have conducted his life on the basis of this principle of economy.

Drawing by Watteau (chalk on paper)

Apparently he had no fixed address, lived here and there, often with friends giving him a room where he could sleep or work. This suggests that he was among those creative spirits for whom the artistic act demands no private setting, no place to call one's own. Of course Watteau might have yearned for these things. We do not know. But the fact is that he spun his world without the security of a permanent place, inventing the particulars of his dreams without the comforting particulars that he would have chosen for himself, rather like the novelist or playwright holed up in the indifferent hotel room, who finds in the immediate nothing a freedom to invent everything. I think of Watteau arriving in some empty studio with a few sketchbooks full of studies of men and women and setting to work, producing within those four bare walls a lustrous, dewy world, a world that exists outside of himself. There is an idea here about the asceticism of creation, about creativity involving a disciplined imagination. The opulence of Watteau's art— the shimmering silks and the sun-dappled trees that are sometimes realized with the daintiness of spun-sugar confections—reflects not an impromptu outpouring of the creative spirit but a careful adjustment of the economics of the imagination. When Watteau goes over the top, it's in a restrained way, for a particular reason. And his asceticism, if indeed that is what we should call it, is not a rejection of beauty but a way of safeguarding, treasuring, enshrining beauty.

Enough. One day in his studio, D said to me: "I've always had enough. I'm tall enough, I'm good-looking enough. I have enough money."

Evening. The streets are turning deep gray-blue and the neon signs are coming on, and there is this eagerness to get together and get a little high and see what happens. Work is over, the trip home has not begun, and people are slipping into bars, into O'Reilly's and the Irish Rose and Dublin House, ties loosened, jackets off, high heels kicked under barstools, men and women together. The seats are all awry and everybody can't quite fit around the little tables, so people are pushed into unexpected encounters, at odd angles to one another, with three or five people involved in overlapping conversations. Or if the exchange is one-on-one, if a man finds himself next to a woman from the other office, someone he doesn't really know, the conversation deepens quickly, which can make it all the more revealing, with the strangeness of secrets casually exposed. But mostly the talk amounts to a hullabaloo, lots of trivial gossip, with nearly everything that's been said, even the most revealing things, quickly forgotten as everybody leaves the bar and the rollicking repartee dissolves in the evening air.

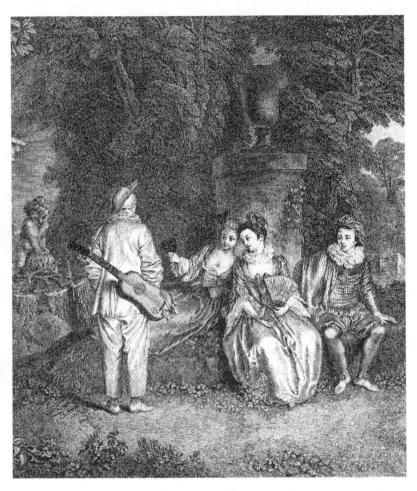

Detail from a print after Watteau, *Party of Four*

F

Fans. A painted fan is a picture in motion, a picture that can be held in front of a face, moved back and forth to circulate the air, dangled strategically in the midst of a flirtation, set down on a table, put away in a bag or a drawer. And if the fan is made of hinged segments and is meant to open and close, as so many fans are, it's a picture that can also vanish into thin air. In their instability and their delicacy, painted fans, these luxurious toys, suggest the ephemeralness of painting, the provisional character of all painting's illusions. The nature of the fan's support, which is mobile, changeable, reminds us of the thinness, the shallowness of even painting's grandest illusions, reminds us that a painting is always a fiction, a screen that hides another reality, just as behind the little pastoral scene the owner of the fan can hide her eyes, her mouth. Among the legends about the origins of the fan there is a story of a Chinese empress at a public audience, masked so that her subjects could not see her face, who became so hot that she removed the mask and began fanning herself with it. This suggests that the fan and the mask grow from the same root, that the fan is a sort of mask.

The fan is, of course, an object associated with Watteau, both because there are women in his paintings who hold

fans and because he himself painted or designed a number of fans. Such a fan is described in one of the essential nineteenth-century novels, Balzac's *Cousin Pons,* where this delicately decorated object sets the whole gigantic Parisian plot in motion. Cousin Pons is a musician with little money who devotes his life to amassing, through an almost impossibly strenuous and cunning exploration of the *antiquaires* of Paris, a great art collection. And it is on one of his forays that he purchases a fan painted by Watteau, which has been discovered in a drawer of an inlaid eighteenth-century desk by a dealer who has no idea what it really is. The fan has a pastoral dance painted on one side and a ball in a fashionable salon on the other, so that the two sides, taken together, symbolize summer and winter, but also nature and culture. Near the beginning of the story, Pons gives the fan to his second cousin's wife, the vile Madame de Marville, who takes a starring role in Balzac's tale of goodness and greed. The fan can look like a very small thing indeed, particularly as the novel gathers steam and Balzac's monstrous cast—the plotting concierge, the disreputable lawyer, the insatiably ambitious Madame de Marville—race to top one another's merciless machinations. And it is one of the ironies of the novel, which ends with Cousin Pons's death and Madame de Marville showing off the fan at some gathering, that she initially had not had the slightest comprehension of its value. This led her husband, a president of the Royal Court of Justice in Paris, to say to her in meek frustration, "You ought to have known about Watteau, my dear. He's in great favor today."

The fan in *Cousin Pons,* unabashedly a plot device, has implications that will multiply, if only you let them. In Balzac's Paris, where society whether high or low is dominated by brutal calculation, there is something infinitely touching about the importance of this fan. At the end of the novel, Madame de Marville is boasting about the gift that she once dismissed and now loves for its astronomical value and its association with Madame de Pompadour, whom Pons believed once owned it. But for Balzac, who understands as much about the aspirations of artists as any writer who has ever lived, the Watteau fan in *Cousin Pons* comes to symbolize painting's elusive, indomitable power, at once utterly unknown and all-conquering, like the fan itself, a mere nothing when folded up but when open, when recognized for what it is, an immortal peacock show, invulnerable in its very vulnerability.

Flaubert. In a memoir, "A Chance Meeting," Willa Cather tells of staying at a hotel in Aix-les-Bains in 1930, and of how she meets an old French woman who turns out to be Flaubert's niece and the editor of the posthumous edition of *Bouvard and Pécuchet.* One evening they find themselves discussing the relative merits of Flaubert's various books. Cather mentions that a few years earlier she had reread *A Sentimental Education,* the story of a young man's coming-of-age in the middle of the nineteenth century, a rather aimless coming-of-age, with Frédéric Moreau living off an inheritance as he searches for love and samples the attrac-

tions that Paris has to offer. *A Sentimental Education,* Cather explains to Flaubert's niece, is a book that she admires immensely, at which the niece shakes her head and offers some reservations, observing that it is "too long, prolix, *trop de conversation,*" and that "Frédéric is very weak." The niece's response is equivocal; Cather detects "an eagerness in her face," a recognition that *A Sentimental Education* is indeed a complicated case. At which point Cather finds herself thinking about the relative merits of Flaubert and Balzac, two nineteenth-century giants who wrote about the passions and hopes and frustrations of young men.

Cather acknowledges that there is a coldness about *A Sentimental Education,* and that this is especially strange in a book dedicated to youth, for youth, as she says, "even when it has not generous enthusiasm, has at least fierce egotism." Balzac, she observes, brings a "gustatory zest" to such stories. He's always "getting into the ring and struggling and sweating" with his characters, and this feverish approach obviously makes a great deal of sense when a writer is evoking the hell-bent emotions of the years when you're only beginning to claim your place in the world. And yet Cather can also see the power in Flaubert's slow, methodical focus on all the details of the life of Frédéric Moreau. Somehow, although this is, as she admits, "a story of youth with the heart of youth left out," by the end of the book the dryness of Flaubert's storytelling has given us the extraordinary sense that this "is something that one has lived through, not a story one has read; less diverting than a story, perhaps, but more inevitable."

And so Cather is left with the question of which one of these novelists is better able to tell us about the lives of young men, Balzac or Flaubert? There is no clear answer. She observes that readers generally begin with Balzac. "To young people he seems the final word. They read and reread him, and live in his world; to inexperience, that world is neither overpeopled nor overfurnished. When they begin to read Flaubert—usually *Madame Bovary* is the introduction—they resent the change of tone; they miss the glow, the ardor, the temperament." *Bovary* is a problem. "The wine is too dry for us," Cather writes, recalling her younger self. "We try, perhaps, another work of Flaubert, and with a shrug go back to Balzac. But young people who are at all sensitive to certain qualities in writing will not find the Balzac they left. Something has happened to them which dampens their enjoyment. For a time it looks as if they had lost both Balzac and Flaubert." But then something more happens, and here Cather arrives at the crux of her comparison. "They recover both, eventually, and read each for what he is, having learned that an artist's limitations are quite as important as his powers; that they are a definite asset, not a deficiency, and that both go to form his flavor, his personality, the thing by which the ear can immediately recognize Flaubert, Stendhal, Mérimée, Thomas Hardy, Conrad, Brahms, César Franck."

No point is more important. Great artists are limited, at least nearly all of them are. But their limitations, so Cather is suggesting, are a part of their power, perhaps the key to their power. Art is the intensification of limitations, the

shaping of limitations, the transformation of limitations into qualities of form and feeling.

Flirtation. Nothing much happens in Watteau's paintings, aside from an endless round of flirtations, a grandly pleasurable buildup to pleasure or to the possibility of pleasure. There is also, however, a confounding or distracting or confusing of amorous signals, so that love's arrows, far from ever flying straight, do corkscrew curls, ricochet, bounce, float, zigzag in a scattering of patterns that are like nothing so much as the diagrams abandoned by a mad scientist on a blackboard. So how are we to understand these paintings that are a never-ending plot of come-ons, importunings, seductions, rejections, equivocations, retreats? What precisely does flirtation mean? I found myself thinking about all this after a friend, standing in the middle of his office heaped high with books, gave me his new one, *The Flirt's Tragedy,* a quickening excursion through Victorian and Edwardian fiction, which actually begins in the present, with Milan Kundera's novel *Immortality* and the thought that "immortality does not adhere to romantic passion per se but rather to passion's calculated postponement." Reading that sentence on the bus back from my friend's office, I realized that in a sense passion's calculated postponement is Watteau's essential subject, so that his paintings become a meditation on the possibilities and impossibilities of love, a meditation on the chance that two people might come together, might for at least a time be turned into one.

Watteau's paired lovers, locked in their agonizing, delicious indecision, are emblems of the ever-approaching and ever-receding possibility of love. You may argue that Watteau's paintings of his contemporaries are an exploration of the possibility that love can change the world, and in this sense they are, like many works by Titian and Poussin, responses to love stories from classical mythology. But with Watteau the story is never complete. You try to join your destiny with another's, but you can't. Or at least you fear that you can't. Flirtation becomes for Watteau's men and women a perpetual process of becoming—a myth for modern times. As the young lovers fritter away their afternoons in the charming gardens, the old romantic love stories are collapsing. And the lovers' gestures—the touching, the looking, the looking away—are a fracturing, an abstracting of love's grand narratives, a fracturing that shatters the authority of the narrative, creating curiously enigmatic images. What we are witnessing is something like the death of storytelling, or at least the thickening or slowing of storytelling, until the parts of the story—the young man's arms extended in a near embrace, the young woman's head turned away in doubt—are so magnified as to refer only to themselves. All of love becomes a sketch, a rehearsal, an episode in an experiment that can never be completed.

Fragments. To define the fragment is to define an enormous, amorphous category. In his dictionary, Samuel Johnson calls a fragment "a part broken from the whole; an

imperfect piece." And since things are always getting broken, there always have been and always will be fragments, which people gather up, if for no other reason than to move the debris out of the way and get on with the business at hand. Fragments are abrupt. They show their battle scars; their broken, irregular edges can be highly suggestive. They've been acted on in unexpected, unwelcome, sometimes mysterious ways. Fragments can be ordinary or rare. They can also be a bit of both; consider a humble piece of pottery that is shattered in one century and recovered centuries later, when if not unique, it is certainly no longer ordinary. Among the items that can be categorized as fragments are a piece of the True Cross, a scrap of music, a memory. And much of the fragment's fascination has to do with its delicious air of possibility, for a fragment provokes a partial experience that can leave us with a heightened awareness of what we are missing.

But what of the idea of the fragment as something consciously created? Certainly there is a fascination with the fragment in many of Watteau's drawings, in those sheets where we find a hand, another hand, a head, all of them somehow connected, but each of them also considered in its rapturous isolation? Perhaps something that Rilke wrote about Rodin's hundreds of sculpted studies of hands is relevant here. He said Rodin had created a "history of hands; they have their own culture, their particular beauty; one concedes to them the right of their own development, their own needs, feelings, caprices and tendernesses." In isolating the part, Watteau may be pointing toward the fragmentation of our feelings, our perceptions.

Drawing by Watteau (chalk on paper)

Friendship. Montaigne said that friendships are the freest of all relationships. And in the open-ended ambience of the creative life, where there are no sure things and career paths are not marked out and the advice of parents and teachers frequently proves useless, the friend with whom to talk, to see things, to make a community, to invent an audience, to experience the ups and downs, the friend to tell you when you're off track, to celebrate your progress, to give you your chance—this friend can scarcely be done without. Of course, in many if not all the tales of bohemia, friendships are flattened, obliterated, swept aside—by the struggle to get ahead, or by the tidal wave of a great love affair. Love in bohemia—to some love is the core of bohemia, and who can doubt that there is some truth

to that? But if love among the artists is the celebration of the senses, the passions, the deepest and wildest and least controllable inclinations, then friendship is an attempt to recreate some idea of civil society, but a society without the fixed assumptions of society. So the grandest bohemians are both lovers and friends. Think of Picasso, whose friendships, certainly in his earlier decades in Paris, were as important as his love affairs, and whose friends are the subject of a veritable portrait gallery, from Carles Casagemas, the painter whose suicide reverberates through the work of the Blue Period, to the powerful drawings of Max Jacob, Guillaume Apollinaire, and so many others. Picasso's friendships frequently shifted, as did his lovers, but at least in Paris the lovers were always surrounded by the friends, for friendship is a perpetual reinvention of the idea of social existence, an exploration of the extent to which private feeling can be projected into the public realm, a realm of feeling and caring that exists apart from the rule of law and the inexorable logic of family life.

G

Gersaint's Shopsign. *Gersaint's Shopsign* is the greatest work of art ever devoted to shopping. It is an epic of shopping. It is a poetics of shopping. This panoramic view of an interior where paintings and mirrors and clocks and other luxury objects are for sale is "I shop therefore I am," but reimagined as metaphysics and allegory. Watteau's cast of characters—twelve in all, eight men and four women—move with the semaphore-like gestures of marionettes; they are puppets in a story of desire. The *Shopsign*, painted in tones of black, gray, and rose, is at once adamantine and airy—a vision that, despite its funny moments, is strangely somber, almost ritualized. At center stage there is a young man, elegant and ardent and maybe even a little grave, standing just inside the shop, offering his hand to a woman who steps in off the sidewalk, her back side, which is what we see of her, a great shimmer of cloth. Each of the dresses in the *Shopsign,* and this one in particular, has a gleaming, shivering life of its own—they're couture creations that function independently of the bodies they contain, they're lengths of beautifully made and sewn cloth to be played with, petted, adored. The desire for clothes and the desire for flesh melt together, and indeed this is very much a painting about elements that fit into or turn into one another, the

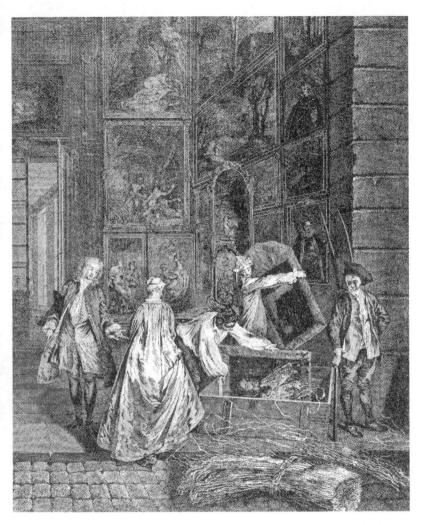

Detail from a print after Watteau, *Gersaint's Shopsign*

nude into the clothed, the bare canvas into the framed mas-
terpiece, the box as a container for a painting or for a set of
toiletries, the mirror as a framing of the passing parade, the
picture frame that frames not only the painting but the peo-
ple who look at the painting.

Our feelings about things, our perceptions of things are
always multiplying, or at least they are always slipping into
other feelings, other perceptions—this is what Watteau
wants to tell us. Nothing is only one thing, even, maybe
especially, the visit to the shop where luxury goods are sold.
William Cole, an English visitor to Paris in the 1760s, a
generation after the *Shopsign* was painted, suggests the
quotidian experiences that went into Watteau's composi-
tion when he describes Madame Dulac's "extravagant and
expensive shop; where the Mistress was as tempting as the
Things she sold." The beauty of the objects and the beauty
of the proprietor could not easily be separated in Cole's
recollections, and of course this is all tumbled together with
the fact that even when an object of desire has no direct
relationship with sexual desire—when the luxury is, say, a
beautifully bound book, an old master drawing, or an espe-
cially elegant clock (like the one in *Gersaint's Shopsign*)—
the pleasure of possession can be so intense as to acquire
an erotic dimension. The object that is purchased from
Madame Dulac, so Cole explains, is bought not only for
itself but "to remember where you bought it"—and from
whom.

The luxurious bauble can also have symbolic implica-
tions, so that the purchase becomes an endorsement or

embrace of certain ideas. There are the Northern Renaissance paintings of the marriage couple making a visit to the jeweler's, where the gold is being weighed, and all sorts of thoughts about love, loyalty, faithfulness hover in the immaculately rendered air. In Titian's portraits, the appearance of one of the newly fashionable clocks on a little table is at once a sign of the subject's great wealth and a memento mori. And then there is the golden bowl, of gilt crystal, after which Henry James named his last completed novel. The secret lovers, Prince Amerigo and Charlotte, are wandering the streets of London and chance upon a "small but interesting dealer in the Bloomsbury street," who shows them the great bowl, with its decoration that is almost Byzantine in its ornamental elaboration. Charlotte, who is considering buying the bowl as a wedding present for the woman the prince is going to marry, falls into a conversation with the proprietor. "Does crystal then break—when it *is* crystal?" Charlotte asks. And when she is told that "it splits—if there is a split," she responds, "Ah! If there *is* a split. There *is* a split, eh? Crystal does split, eh?" To which the shopkeeper responds, "On lines and by laws of its own." And Charlotte replies, "You mean if there's a weak place?"—at which point we are speaking not about the bowl but about human relationships and human society.

In *Gersaint's Shopsign*, Watteau keeps moving from the snapshot of everyday life to the allegorical spectacle and back again, and it is the constant shifting between registers that gives the painting its devious power. Watteau painted the *Shopsign* near the end of his life, for one of his great

friends, the art dealer Edme-François Gersaint. It was meant to hang as a sign above the entrance to the shop on the Pont Notre-Dame, Au Grand Monarque, where Gersaint sold paintings and other luxury objects, and it is said to have created a sensation in Paris during the brief time that it actually was displayed out-of-doors. The painting does not represent Gersaint's actual premises in the arcades of the Pont Notre-Dame, which were narrow and dark. And Watteau would probably have said of this shop much what Henry James later said of the Bloomsbury antiques shop in *The Golden Bowl,* namely that it "was but a shop of the mind, of the author's projected world."

The walls of Gersaint's shop are practically papered with paintings in elaborate frames. These are not miniature versions of actual paintings but rather Watteau's imaginative variations on the art of the Baroque, a recapitulation of all the passions, sacred and profane, that have kept the world spinning. A resplendent clock reminds us that youth and love will end. Two large mirrors, each a dark abyss, suggest the impossibility of knowing oneself, even as two young men look lovingly at their own images in another mirror. And then there is the elegant lacquerwork toilet set. Who can doubt that toiletries, mirrors, and a clock raise certain questions: Who are we? What can we make of ourselves? What will we become? But the answers to these enormous questions are as remote as the empty room that is glimpsed through the doors at the back of the bustling shop, a room at once outside the main action and at the center of the painting, a room where a nacreous green-gray light, evoked

with lightly hatched strokes of paint, dances over a world bereft of people and paintings and objets d'art. (At least one scholar has seen in that empty back room a vision of heaven or paradise, which makes a certain amount of sense.)

Within this elaborately appointed interior, Watteau has set a dozen characters as well as a dog. The *Shopsign* is a world of doublings, maybe even triplings—a painting about the buying and selling of paintings and other precious objects in which the men and women who have come to shop are themselves the most luxurious objects of all. In that quiet way of his, Watteau makes of this dozen delightful figures a geometric game, giving us four men and one woman on one side of the painting and four men and three women on the other side. He plays with couples—a man and a woman, two men whose looks suggest mirror images—but he also gathers his figures in threes and fours and fives, as if he were a choreographer exploring the full range of physical possibilities. And in addition he plays with a range of social classes, from the workmen to the shopkeepers to the customers, who are either aristocrats or wealthy commoners suddenly hungry for luxuries. So we have three or four classes represented, each of which Watteau treats in the same gently comic manner. Each is part of the passing parade, and of course nothing is fixed, as we are reminded by the workman at the side who is packing a portrait of Louix XIV, recently deceased, into a case, the portrait both alluding to the name of Gersaint's shop, Au Grand Monarque, and suggesting, at least in our retrospective gaze, the passing of the Sun King's world.

Detail from a print after Watteau, *Gersaint's Shopsign*

And just as history is constantly changing, so are percep-
tions, as we see in the most playful incident in the *Shopsign*,
which involves the salesman who is showing to a couple a
large oval painting of a pastoral landscape with figures.
While the woman, a dutiful connoisseur, examines the

artist's handling of the great, feathery trees, the man is busy feasting on the female nudes in the foreground. This little anecdote might be labeled: Two ways to look at a painting. And then there are those who have eyes only for themselves. Even as the young shop woman shows off the fine lacquer toilet set, the two men to whom she may be making her sales pitch appear less interested in looking at the toiletries or, for that matter, at the pretty salesgirl than in admiring themselves in a little mirror.

Legend has it that Watteau painted the *Shopsign* in eight mornings, as if he were God creating the world. For Watteau it was a great new beginning, a dramatic turn from the pastorals that had preoccupied him for so long. But the *Shopsign* was also done in the twilight of his career, so that its revolutionary zeal was tinged with nostalgia, as if Watteau were saying, "Yes, this is where I might have gone, this is a whole other sort of thing that I might have done." It is the painting that inaugurates the work of all the painters whom Baudelaire, a century later, would be thinking of when he dubbed Constantin Guys the Painter of Modern Life, but *Gersaint's Shopsign* is also the greatest painting of modern life ever done, a premature requiem for the Painter of Modern Life. Some have wanted to see the artist's self-portrait in the lithe young man at the center of the painting, the man who, with his sharp, bright, dark eyes, is looking so longingly and invitingly at the young woman. The story of the self-portrait, like the story of the painting having been completed in eight mornings, may be apocryphal. But it hardly matters. That young man who is not Watteau is

surely the spirit of Watteau. And here he is, reaching out his hand to this woman who is among the last women in Watteau's art whom we will see from behind. And he invites her to join him in the dance of life, dancing oh so slowly, as the world passes by.

H

Happiness. The power of improvisation, the power of variations on themes, the power of doing what you have already done but with a somewhat different inflection or intonation or intensity—this is happiness within tradition.

Harlequinade. One night, over dinner in an old Italian restaurant on Houston Street, a writer friend was enthusiastically taking up the cause of Watteau. This friend's interest in the painter might have struck some as a surprise, as he is known for his grave considerations of the worldwide threat to democratic institutions and aspirations, and for his fervent defense of liberalism. But as we sat there on East Houston, as he talked and I tossed in some remark or other and then he talked and talked some more, it occurred to me that the complexly circuitous manner of my friend's conversation, his love of arguments that are all zigzags and meanderings, has some of the quality of an arabesque or a capriccio. In order to establish a fundamental truth, my friend feels that he has to explore many curving and curling and angling ideas, he has to immerse himself in a sort of rigorous intellectual play. And then it occurred to me that his presence at a dinner table often suggests something of Har-

lequin's ebullience. Compact and intense, with sharp features and an insistent look in his eyes, he sees conversation as performance, and accents his verbal twists and turns with hand gestures that have some of the dramatic wit of the hands in figures by Callot, whose engravings of commedia dell'arte characters prefigure Watteau. In conversation, my friend is a likable aggressor—an actor in the harlequinade. He is always at play in his own seriousness, fascinated by the arc of an idea, and then absorbed by the trick of catching the end of this arc and launching from its powerful trajectory yet another trajectory of thought. He's a juggler of ideas. There is an element of self-absorption about his conversation, but there is also an effort to escape from the tightly elegant verbal tangle that he has himself designed, to discover the pattern that guides his mental arabesques.

Helen of Troy. Who is the most beautiful? And how do we judge? And who is to be the judge? These questions are given a tangled, ambiguous, sharply sardonic treatment in the ancient story of the Judgment of Paris. And it cannot be insignificant that this is among the few themes Watteau ever borrowed from classical mythology, for it is a story that is anything but straightforward, a story in which judgment is anything but pure. Zeus, confronted with the prospect of determining whether Juno, Minerva, or Venus was the most beautiful, decided that he was unwilling to take the responsibility, so he sent them to see Paris, a shepherd prince who had recently shown considerable wisdom in judging

Drawing by Watteau (chalk on paper)

another contest. But when confronted with the three gorgeous goddesses, each of whom offered him a bribe, Paris turned out to be far from disinterested. He awarded the prize to Venus after she promised him Helen of Troy, the most beautiful woman in the world. Helen, however, had to be abducted from King Menelaus of Sparta, to whom she was already married, and so began the Trojan War.

The story is as much about the difficulties of judging beauty or grasping beauty as it is about beauty itself—for Zeus does not want to make a judgment, Paris's judgment is compromised, and when Paris claims his prize, a horren-

dous conflict begins. I would guess that the ambiguities of the legend appealed to Watteau, a student of female beauty who was uneasy with the traditional standards of beauty, who was looking not for an ideal beauty so much as an ideal of the real. Watteau wanted to discover a modern conception of beauty, a constant pressure of real and ideal, a never-fully-resolved beauty—you might call it a nearly cinematic beauty, a beauty that is continuously emerging from the shifting impressions of the moment and leaves the ardent lover crying, "I can't stop looking at you!" Watteau understood that in order to paint the most beautiful woman he had to plunge into this play of glances, this maelstrom of vignettes, until the gathering intensity of the overlapping images shocked his contemporaries into the realization that they had witnessed the creation of an ideal woman, of Watteau's woman. And who is this woman? Well, she has a slim physique and small breasts, sharply yet delicately shaped hands and feet, a face with softly yet exquisitely defined planes, and a general quality of being undressed even when she's dressed.

Watteau's women—Watteau's *woman*, his Helen of Troy, alone in her bed, her flesh shimmering like jewels on dark velvet—suggests a late afternoon world where the classical ideal has all but perished and the modern ideal has not yet been born. It was as he immersed himself in the great adventure of his graphic work, constantly drawing the actresses and wives and mistresses whom he knew, that Watteau developed his improvisational alternative to the copybook of classicism, and created a new kind of woman,

a woman who is a figure in the prehistory of Romanticism. To look at the sheer variety of these drawings, especially the sort of single sheet on which Watteau juxtaposes studies of a woman's head with a close-up of a hand holding a fan or a vignette of the man who might just be the woman's lover, is to witness the anatomization of ardor, the invention of a real ideal. The real woman animates the ideal—it's Pygmalion in reverse. The art historian William Rubin has observed of Picasso that he "chose as muses women who coincided to some extent with preexisting mental images," and that may be true of a number of great artists, or at least so it seems to the modern imagination. Perhaps this is how many people think about the men and women whom they love. In any event, Watteau's woman emerges at the crossroads of fantasy and fact, a silken seductress encountered in some Parisian drawing room who enables the artist to fill in the details of an obsessive mental image. Like Raphael with his mistress, La Fornarina, and Michelangelo with the young nobleman, Tommaso de' Cavalieri, Watteau is both a romantic and a realist, and he finds the fulfillment of a fantasy, the key to beauty as an idea and an ideal, amid the flesh-and-blood figures of the here and now.

Hyphenated. I have read about a Romantic-Pierrot, a Lunar-Pierrot, and a Watteau-Pierrot, each of which describes some artistic variation on the original Pierrot, the slapstick Pierrot of the old commedia dell'arte. The hyphenations suggest how difficult it is to describe all the

variations on this comic in the floppy white suit, for the scholars can't seem to help but become jugglers of meanings, much as the artists are. Pierrot becomes a romantic poet, a figure as elusive as a moonbeam, or an eighteenth-century gallant. The literary critic Frederick Karl describes a Dandiacal-Pierrot line that runs through modern literature, which thus connects Pierrot with an attitude of artistic detachment, at once witty and aloof and snobbish and austere, so that Baudelaire turns out to be a sort of Pierrot. Karl, however, draws the line at Proust, whom other people see as very much the Pierrot. I get a kick out of the loopiness of these scholarly arguments. It's superbly brainy conversation. There is a pleasing madness to all the hyphenated meanings, as if the scholars themselves were getting a little drunk on the possibilities of Pierrot.

I

Impresario. "I was scared stiff," the dancer Lydia Sokolova recalled of her first meeting with Diaghilev in 1913, when his Ballets Russes had already been mesmerizing audiences in London and Paris for four years. "His presence was awe-inspiring and he radiated self-assurance, like royalty. Tall and heavy, with a little moustache and a monocle, he advanced into the room, followed by a group of friends. Everyone who was seated stood up, and silence fell. . . . He passed through the crowd of dancers, stopped here and there to exchange a greeting. Any male dancer to whom he spoke would click his heels together and bow." This dark, imposing figure, the greatest impresario in the history of the arts, was of course not royalty at all but a brilliant deal maker and world-class cajoler who would spend the frantic years until his death in 1929 begging and borrowing from wealthy lovers of the arts in city after city, riding the roller coaster from feast to famine and back again, even as he was pushing Fokine, Nijinsky, Massine, and Nijinska to transform the nature of dance, provoking some of Stravinsky's greatest music, introducing Paris to the exoticism of Russian color and pattern, and then abandoning his Russian stage designers in favor of the School of Paris and Picasso, Derain, Braque, Gris, and Matisse. There

were great popular triumphs: *Specter of the Rose*, with Nijinsky's leap; *La Boutique fantasque*, a Victorian fantasy with sets by Derain and Massine in the cancan. There were avant-garde landmarks: *Afternoon of a Faun*, with Nijinsky, at the very end, heaving his body as he masturbated, and *Rite of Spring*, the movement choreographed by Nijinsky with a blunt force unknown in ballet. And there were also extraordinary explorations of the ballet tradition, especially *The Sleeping Princess*, Diaghilev's resplendent resurrection of *The Sleeping Beauty*, an homage to the genius of Tchaikovsky and Petipa, a landmark in the history of the dance that was mounted in London at fantastic cost, impossible to recoup. But mostly, for Diaghilev, there were the endless hotel rooms and train trips, the desks heaped with unpaid bills, the creditors at the door, the sudden infusions of money, the great opening nights, with all the fashionable world in attendance. "We always knew when Diaghilev had been successful after one of his Paris trips," Sokolova recalled, "because Massine would be wearing another sapphire ring on his little finger. Massine, like Nijinsky, collected several of these, but whereas Nijinsky's had been set in gold, Massine's were set in platinum."

Diaghilev amid his company of youthful, extraordinarily charismatic dancers, several of the greatest of whom, Nijinsky and Massine especially, were his lovers, is in some respects a solitary figure. The caricaturists had a field day with Diaghilev and his young men, the puffy middle-aged man, his profile practically spherical, parading with the sleek, slim friend. And in the unabashedness of Diaghilev's

situation, its absurdity defied by his determined sense of self, I can see an echo of the curious dancer in Watteau's *Venetian Pleasures*, the middle-aged man with the turban and the not exactly svelte figure who is dancing with an exquisite woman in palest blue, his hands on his hips, surrounded by younger, or at least more youthful looking men and women. The identity of this man is known, he is Watteau's friend the painter Nicolas Vleughels, born in 1668. Watteau lived with Vleughels for about a year in 1618–19, and later in his life Vleughels became the director of the French Academy in Rome.

Vleughels would have been in his late forties or very early fifties when Watteau painted *Venetian Pleasures*, roughly the same age that Diaghilev was when the Ballets Russes was at the height of its power around World War I. With the Ballets Russes, Diaghilev reinvented the commedia dell'arte, literally in *Carnaval* and *Pulcinella*, but in a larger sense, too, in the playfulness of *Boutique fantasque*, and in the white costumes of the tennis ballet *Jeux*, a ménage à trois with Nijinsky as the man in the middle. Even a cursory examination of Diaghilev's biography underscores one's sense that the Russian impresario, not unlike Vleughels in *Venetian Pleasures*, was a formidable figure but also more than a little odd, a middle-aged man in the midst of a gaggle of much younger artists and dreamers. Perhaps he was never quite fully in control, at least not to the extent that he would have liked to have been, for both Nijinsky and Massine, the dancers whom he loved and to whom he gave commedia dell'arte roles, finally eluded his grasp. Both men

Detail from a print after Watteau, *Venetian Pleasures*

were essentially heterosexual; Nijinsky married Romola, and Massine, even in the years when he was living with Diaghilev, was sneaking off to brothels.

Diaghilev made it possible for Nijinsky and Massine to

shine in a commedia dell'arte world, and yet when they were onstage they were so completely liberated by the roles they played that they were independent spirits, released from the impresario's spell. The artists who most completely embody a role also dissolve the role: that is the enigma. Cyril Beaumont, recalling Nijinsky as Harlequin, described a "lithe figure clothed in white tights chequered in red and green, white shirt, and black tie. He wore a black skull cap and half mask. Think of him as one lively as Mercury and as maliciously mischievous as Tyl. Think of him one moment posed in an attitude of mockery, the next bounding and rebounding in the air with the ease of a bouncing rubber ball, or twirling round with the facility and precision of a spun wheel." He was "cynical and sly," Beaumont reported, his smiles "were fleeting and tinged with mockery." You feel here an echo of some of the young lovers, male and female, in Watteau, only Nijinsky was not a figure in a painting but a dancer, a man, impenetrably shy in person, someone you might almost not notice in a room, and yet when he went on the stage, all of Europe was at his feet. And then there was Massine as Pulcinella, also recalled by Beaumont, "his features were almost hidden by his bird-like mask," which had been designed by Picasso. "Yet it was extraordinary to observe how, by the tilt of his head and the angle of his body, and by the varying speed and variety of his movements, he was able to suggest his thoughts and emotions. When I saw his subtle, intensely expressive, and beautifully timed dancing, I was reminded of Garrick's comment on the Italian Harlequin Carlin—'Behold

how the very back of Carlin has a physiognomy and an expression.' "

And so here we are, with Massine and Nijinsky and Diaghilev, two hundred years after Watteau, witnessing the recapitulation of Watteau's world: the fleeting, mocking smiles, the impossible liveliness, the archetypal back view, the masking and the turning away that can reveal so much. The dancer onstage, Nijinsky as Harlequin or Massine as Pulcinella, confounds the impresario who has made the occasion but must finally step aside. And we might even see in the relationship between the impresario and his company a metaphor for the situation of the artist. The artist can never fully control his creation. The work of art eludes the creator's grasp, takes on (one hopes!) a life of its own. If the work of art is going to live, it must eventually turn its back on the artist, it must go its own way.

Detail from a print after Watteau, *The Shepherds*

J

Joke. I saw her in Berlin, in a painting in the Charlottenburg Palace. Her back is strong and trunklike, her raised arms are two limbs, she is sitting in the swing between the two trees, a young woman in silhouette, painted by Watteau in greens and yellows that suggest the coloration of a tree, so that she indeed becomes a tree. We see the back of her dress, her lower arms, her hands holding the swing, her upswept hair, the nape of her neck. And her entire form becomes a singular image, its immobility all the more strange, shocking really, for being fixed in the potential mobility of this immobilized swing.

A young man, beside the swing, has taken an interest in her, but what she feels we can't be sure. We do not know if she is in thrall to a particular boy, or to boys in general. For all we know, she might have forgotten about the young men and women who are gathered near the swing around a bagpiper, flirting and talking and dancing. Perhaps she is mostly in thrall to nature, suggesting the poem that Ezra Pound titled, simply, "A Girl," in which the girl exclaims, "The tree has grown in my breast—," and then, "The branches grow out of me, like arms." Except that Watteau's composition has nothing of the gentle melodrama of Pound's brief soliloquy but gives us, instead, this young

93

woman who is faceless, who so far as we can tell is saying nothing, who is so beautifully framed by the trees that surround her that she is becoming nature, a girl becoming a tree much as Daphne, fleeing Apollo, was turned by Zeus into a laurel tree. The difference is that here the girl in the swing, with her reverie that is erotic or careless or careworn, but mostly from our vantage point enigmatic, has succumbed to a metamorphosis that is no longer a game played by the gods but a painterly joke, and of course part of the joke is that the painter is playing God as he uses a dappling of paint strokes in forest colors to turn her rustic gown into rusticity itself. She is a character out of Ovid's *Metamorphoses* reimagined, still infinitely strange but with the strangeness turned into painterly comedy, a girl saved from love's turmoils and violence by becoming the girl who sits dreamily in the swing amid the trees and, lo and behold, becomes the tree itself, suggesting, as Pound observes of the girl who becomes a tree in his poem, "And all this is folly to the world."

Jullienne. One afternoon in the fall of 1728, seven years after Watteau's death, four of his friends were gathered in the home of Jean de Jullienne to look at the just completed *Les Figures de différents caractères*, two luxurious volumes containing three hundred and fifty etchings after the master's drawings, on which Jullienne had been laboring practically since their friend's death. The light had a platinum chill about it that afternoon, as they raised a glass to cele-

brate this monument to their friend, a monument that they knew was unique, for nobody had ever before thought so lovingly to commemorate a draftsman's gifts. The dealer Edme-François Gersaint, for whom Watteau had painted the *Shopsign*, was there that afternoon. And Pierre Crozat, the great collector in whose house Watteau had stayed for months, studying the drawings by Rubens and Van Dyck, leaving a sheaf of his own drawings as a thank-you gift when he departed. And so was Abbé Haranger, who had gotten to know Watteau because he, too, was a collector but had helped him find his final refuge, the house at Nogent-sur-Marne, and had talked about religion with the artist in his last, desperate days, when Watteau found himself thinking about God and feeling increasingly guilty about all the women whom he'd undressed or fantasized about undressing in all his studios, so that he was now going through his drawings, destroying those he felt might cause a scandal.

For each of the friends gathered at Jullienne's place that afternoon, there had been something quicksilver about Watteau, something compelling yet cool. These were extraordinarily successful men, sitting around Jullienne's table. Jullienne himself was immersed in the family business, running the weaving and dye works at Gobelins. Gersaint presided over one of the most elegant shops in Paris. Crozat was a great financier, with a huge house on the Rue de Richelieu and an elaborate estate at Montmorency. The Abbé Haranger was canon of Saint-Germain-l'Auxerrois. And they had all found something fascinatingly elusive about Watteau, who seemed anxious to slough off the trap-

pings of success, who appeared indifferent as to how much a painting could bring and was so ambivalent about becoming a member of the Academy that he took five years to finish *The Pilgrimage to the Isle of Cythera*, which he had to submit before his membership became official. There was a certain charm, they had to admit, but also something downright weird, about Watteau's refusal to hustle. He was a figure in the salons where art and literature were discussed, yet he held himself apart, registering what was going on around him almost seismographically, through the endless flow of his drawings, the outpouring of studies in red and black and white chalk that had kept his friends mesmerized while he was alive.

Jullienne remembered the long walks Watteau had taken with Jullienne's young wife. He was flattered that the painter admired her beauty. And he was charmed when Watteau would return from these walks with exquisite studies of the countryside that made the terrain around Gobelins look like nothing so much as the landscape behind a Venetian Madonna by Giorgione or Titian. Gersaint remembered turning the pages of one of Watteau's sketchbooks, and finding there a sketch of the young actress whom everybody had been noticing that season, an actress who had apparently been perfectly delighted to lie down on the floor of some room that Watteau had borrowed as a studio, the fabric tight across her behind, leaving Gersaint thinking, Damn him, he's gotten her, too, although nobody was quite sure whether Watteau had slept with all of these beautiful women, or only a few of them, or perhaps hardly any

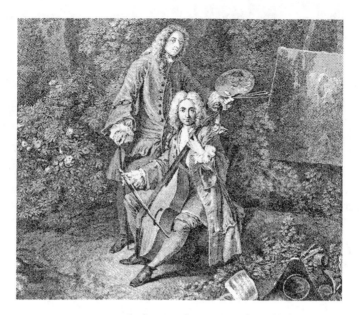

Detail of a print after a painting, possibly by Watteau, of Watteau and Jean de Jullienne

of them. If he had indeed been a Don Juan, he'd been very discreet.

But now that Watteau was gone, the terrible question hung in the air, Had he done enough? As a painter he was not always so convincing as he was as a draftsman, at least that was what some people said. Of course he was a great intellectual, spending long afternoons, so Crozat recalled of his visits to Montmorency, rereading Leonardo's *Treatise on Painting*, perhaps lingering over the famous remarks about seeking the inspiration for a painting in the shapes of the stains on a wall or the clouds in the sky. If only Watteau had had a sounder education, had not begun life in Paris doing

cheap copies of religious pictures and then decorative panels for elegant drawing rooms, perhaps he would have been able to really triumph as a painter of history, as a painter of complex narratives.

"I don't remember him saying much about art," Crozat commented, his eyes cast down, examining an especially pretty landscape in *Les Figures de différents caractères*, "except, perhaps occasionally to comment that some merchant had sent him the wrong chalk from Paris, that the only kind soft enough to really work with was the English kind." "Well, he didn't ever say much," Jullienne added, "but what he did say he said beautifully." What Jullienne was thinking about right then, though, was something he didn't especially want to talk about, for when he was first beginning to know Watteau he had been working at his own painting, in the spare hours when he wasn't immersed in the family business. And when he'd shown Watteau a few of those paintings, Watteau had looked and looked and then said, ever so gently, "I don't think you should be painting, perhaps you'd be better off trying etching, perhaps begin by copying something by Teniers, a scene of men smoking in a tavern, something like that." And so Jullienne had not painted again, and had felt, strangely enough, somehow flattered by Watteau's dismissal, glad to know that his artist friend at least took him seriously enough to tell him that what he was doing was not serious.

"The landscapes are especially beautifully etched," the Abbé Haranger observed, as he looked over Crozat's shoulder at a vista that was in fact on the financier's own property

at Montmorency. "Yes," Jullienne came back, "they're by Boucher, that young man who has such a wonderful touch, who wants to paint, and who was simply crazy for the opportunity to see so many of Watteau's drawings." "The drawings, the drawings," Gersaint muttered, half to himself. He was thinking about Watteau's last hours, when the artist had asked Gersaint, who was sitting on a chair by his bed, to supervise the division of the drawings in four equal parts: to Gersaint, Jullienne, Haranger, and Nicolas Hénin, who had been the steward of the king's gardens and houses and had frequently drawn side by side with Watteau, and who would have been here this afternoon, too, if he hadn't died four years ago, a man in his early thirties. Money and memories, memories and money, that was part of what this huge cache of drawings had been about. There was lots of money to be made off them, and in the years since Watteau's death, Gersaint had sold most of what he'd had.

And now, turning over the pages of these opulent volumes, Watteau's friends were contemplating the spirit of youth itself—of young manhood, of the young century. Had Jullienne given the plates a particular order? The drawing of those two sisters, the talented singers who had seemed to be everywhere until they had married and moved back to the South, was followed by a couple of landscapes, and a drawing of an old beggar woman, and then one of St. Francis in the wilderness. There was a magnificent disorder about *Les Figures de différents caractères*, and Gersaint found he rather liked that, for it suggested a great, unedited ingathering of experiences, sensations, apprehensions. And

although it was Jullienne who had put the volumes together, the informality with which the images were arranged, the helter-skelter mingling of themes and variations, the sense of the imagination as a fluid substance, its shape constantly transformed by the turmoil of memories and feelings—all of this reminded the men who were gathered in Jullienne's house of their old friend, of his informality, his elusiveness, his let's-try-it spirit, for Watteau had urged them to believe that the greatest art, the art that finally had an adamantine logic, began in a spirit of play. The landscapes—with pollarded trees near rushing water, rustic farm buildings, shadowy allées, an elegant garden with fountain and pavilions—filled Watteau's friends with nostalgia for the times they had spent with him, and indeed one scene, of buildings by a canal, was of Jullienne's place in Gobelins, the very building in which they were now sitting, looking at these etchings.

But then *Les Figures,* from start to finish, struck Watteau's friends as the great album of his life—and of their lives, too. To turn the pages was to see a world careen by. There were the young men and women who had gathered in the Parisian salons and in the gardens in the city and beyond, and many of the faces were recognizable. And there was so much more, too: the Pierrots, one holding a guitar; the soldiers who had fascinated Watteau when he was younger and at home in Valenciennes; women begging; a man sharpening a knife; a painter, almost a caricature, at his easel, drawing a single elongated, curling line on his canvas; a young monk reading a book. The images came

quickly, juxtaposed in no particular order, and yet their succession was highly suggestive. In the couple of studies of St. Jerome in the Wilderness the friends were reminded of Watteau's love of solitude. And then there were studies for allegorical compositions, several dedicated to the bounty of autumn, with a woman surrounded by babies gathering bunches of grapes. And there was another composition, with two women and a fountain in the form of an urn, evoking the great image from Fontainebleau known as *La Source*.

Les Figures was many things: a scrapbook of the life that Watteau had lived day by day; a reconstruction of his imaginative life; a memory book, a book of recollections; and also a pattern book, a compilation of ideas that other artists might pursue. But who, now that their dear friend was gone, could ever understand the pattern? That was the terrible question. Perhaps Watteau himself couldn't, perhaps that was why he had kept eluding them, changing addresses, restless, uncertain. They had each spent hours, days with him, and yet he had skated by, so that it could not have been by accident that Jullienne had chosen as the closing image in the collection a drawing of a skating party, with men whirling on the ice, making the arabesques out of which Watteau had spun an entire world. "Why did you close with the skating party?" Abbé Haranger asked without really expecting an answer, because they all already knew the answer. And Jullienne seemed on the verge of replying, an answer was on his lips, but then dinner was announced.

Print after a drawing by Watteau

K

Kleist. One beautiful winter evening in 1801, when the weather was so crisp and clarifying and strangely mild that it felt pleasant to sit for half an hour on a park bench, a writer fell into conversation with a dancer in the public garden of a German town. The writer explained to the dancer how surprised he had been to see the dancer repeatedly watching the puppet theater in the marketplace, a rather crude performance, so the writer believed, with little mock heroic dramas, interspersed with songs and dances. Why, the writer asked, would a man whose performances were already being widely praised for their sophistication take an interest in the unabashedly artificial movements of these marionettes? And in response to this question, the dancer, a man more or less alone in the little town, responded with great volubility, glad to have found somebody who was willing to engage him in a substantial conversation. The dancer hastened to explain that it was precisely the artifice of the marionettes that made them so fascinating, so compelling. He pointed out that there was an extraordinary grace about the movements of these puppets. And this grace, strangely enough, derived from the mechanics of the puppetry, from the extent to which the puppeteer, by holding and moving the strings, gave the dancing wooden limbs

a powerful inevitability—a center of gravity, a geometric elegance. Somehow, the artificiality of the marionette's movements, entirely controlled by a few strings, mostly in fact by one central string, suggested a dance stripped of all the self-consciousness and egotism that absorbed the human dancer. And the result was that the marionette embodied a spiritual power, a kind of purity, which only the greatest dancers ever achieved. The central string by which the puppeteer controlled the marionette was, so the dancer explained, "nothing less than the path of the dancer's soul."

This striking exchange forms the crux of a brief text written by Heinrich von Kleist in 1811, "On the Puppet Theater," which is little more than a meandering conversation, one of those curiously carpentered prose pieces that are characteristic of the Romantic period. I'm not sure whether to call this composition a story or an essay, but however one wants to define it, it has a power that confounds its modest size. Self-consciousness, the dancer is saying, is the enemy of grace, and this explains why grace appears "most purely in that bodily form that has either no consciousness at all or an infinite one, which is to say, either the puppet or the god." This is a paradox, and a stark one at that. At first, the dancer's rather ferocious metaphysics may stop readers in their tracks. But of course it is perfectly logical that a dancer, the product of a strict training, would believe that it is only by forcing your mind and your muscles to obey some superior logic that you can become most fully yourself. The same can be said about the expressive

power of the great musician or the great athlete, whose training involves rejecting many of the quirks and idiosyncrasies that are generally thought to define a personality. And the more that the dancer presses his point, the more compelling his thinking becomes. The playful conversational back-and-forth between the writer and the dancer serves to underscore the metaphoric fascination not only of marionettes but also of other types of puppets, and of dolls and masks and toy soldiers and automatons as well. The dancer is arguing, at least indirectly, that the tender sweetness of a doll, the terrifying emotionalism of a mask, the forthright boldness of a toy soldier—that all of these suggest the crystallization of human feeling, that they are feelings concentrated, epitomized. Kleist's dancer believes that the suppression of certain impulses that we regard as essentially human can become an affirmation of what is most deeply human.

Artists, from ancient times to our own, have understood the power of the denaturalized or stylized human figure, a power that is human and more than human, a heightening or complicating of the human. Just think of the Cycladic idol, the Egyptian pharaoh, the Greek kouros, the Romanesque Madonna, Adam and Eve in Poussin's Garden of Eden, Seurat's Parisian pleasure seekers, Klee's children and acrobats and dreamers, and Giacometti's urban ghosts. What we respond to in all these hieratic images—in these figures that have been geometricized, conceptualized, exaggerated in one way or another—is not unlike what Kleist's dancer has responded to in the puppet theater in the market-

place in the wintry German town. And there is a similar quality in some of Watteau's greatest figures, a sense of their being doll-like or puppetlike, with their arms and torsos and legs sheathed in exquisitely colored silks and their expressive heads and hands as delicate as pieces of porcelain that can be turned this way and that. Of course Watteau derived his figures from life drawings. The hieratic is set in a tension with the naturalistic. But his close study of the theater and the dance enabled him to break with the representational image, so that his sketchbooks finally became a sort of improvised anatomy from which he carpentered these figures that amount to wonderful theatrical toys.

There is something in the unnaturalness of all these images—ranging from the Cycladic idol through the couples in Watteau's *Shopsign* to Klee's acrobats—that accords with our natural yearning to behave in a certain way in the world, to behave in a way that has a saving simplicity, a basic logic. I'm thinking of those times when you are walking down the street, your body moving clearly and cleanly, almost involuntarily; or sitting at a table with one or two or three other people, engaged in the simplest geometry of conversation; or lying in bed, side by side with another person. Sometimes, in these quotidian moments, we feel that purity of which Kleist speaks, we are freed from the naturalism of our egotism and our anxiety— we're quite simply, transparently *there*, we achieve a certain grace, what e. e. cummings was thinking of when he wrote,

any man is wonderful
and a formula
a bit of tobacco and gladness
plus little derricks of gesture.

Drawing by Watteau (chalk on paper)

L

Liberal Spirit. The rococo style of the eighteenth century, with all its arabesques and capriccios, with all its glorious, endless meandering movements, is a dissent from absolutism, a rejection of the authoritarian vision. This is not to say that the arabesque, that most characteristic eighteenth-century form, is nihilistic, not in any way, but rather that it represents a tempered freedom, a constant discovery of the possibilities and limits of freedom. In the process of unfurling all its surprises, its twists and turns and tendrils and efflorescences, the arabesque points toward the center of things, often toward an overarching symmetry that can only be understood through the multiplicity of the artist's darting, looping, careening variations. And all this suggests, at least so I believe, that if we were to articulate a philosophy of the arabesque, it would be a liberal philosophy.

Consider, for a moment, the operations that artists and writers must go through in developing these playful rococo forms. They must begin with a thought or a glimpse or an apprehension and then follow its implications in various directions. They must construct an edifice of images or ideas that is sturdy but not rigid. They must recognize that they will find the heart of things by pursuing what at first

appear to be the most curious divagations and asides. And this way of thinking suggests a search for the center that approaches the center indirectly, that acknowledges that we do not necessarily know precisely where the center is, so the arabesque, which can be as much a verbal idea as a visual idea, becomes an investigative tool. The most famous example of the literary arabesque or capriccio is in *Tristram Shandy*, where Laurence Sterne stops, deep in his novel, to look back and plot the trajectory of his story as a demented scientist might, and actually offers his readers a series of lines, a sort of chart or abstract drawing, complete with bumps and angles going this way and that, representing the journey that the characters have already taken in the novel, so full of detours and diversions. Now this diagramming of the novel's progress is zany, absurdist comedy, but it is a comedy that presents the search for order in the context of a fascination, an acceptance, a delight in life's inherent disorder. The arabesque is a celebration of the elasticity and playfulness of thought, and this effort to find the order hidden in disorder typifies the liberal-spiritedness of the modern imagination.

London. On September 27, 1938, with Germany demanding the annexation of Sudetenland, Neville Chamberlain spoke to the English people on the radio, observing, "How horrible, fantastic, incredible it is that we should be digging trenches and trying on gas masks here because of a quarrel in a faraway country." About that day, Virginia

Woolf wrote to her sister, Vanessa Bell, "Every one was certain it was war. . . . I walked to the National Gallery, and a voice again urged me to fit my gas mask at once. The Nat Gallery was fuller than usual; a nice old man was lecturing to an attentive crowd on Watteau. I suppose they were all having a last look."

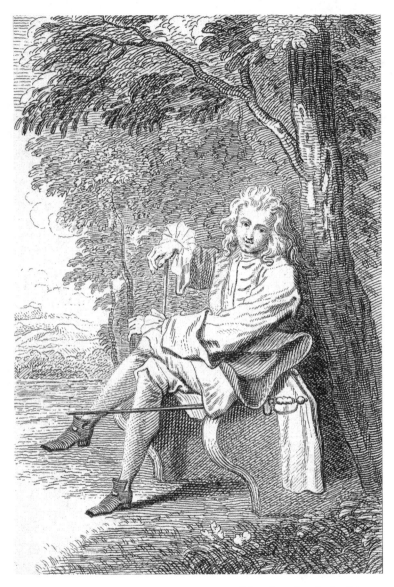

Print after a drawing by Watteau

M

Men. They are the men who appear to be completely at their ease, at any time, even in the middle of the day in the middle of the week. They appear in the neighborhood coffee shop at 10:00 A.M., obviously having just woken up, carrying the newspaper, settling in for a leisurely breakfast. One of them, looking around at the available tables, choosing one that's right along the window overlooking the street, is too old to be a student, yet with a casual, unconcerned air; obligations haven't caught up with him, at least not yet, at least that is what he wants us to think. In the country you see different variations on the same type, sometimes as you drive along the smaller roads, where they are tinkering in the garage in the middle of the afternoon or deep into the night, fiddling with a motorcycle or a dirt bike or a broken air conditioner, the noise of the radio competing with the noise of power tools. I'm thinking of one man in particular, with a run-down house close to the road, his tall frame scarecrow thin, with a wife and two chubby kids, but himself such a dreamer that he is more like another kid, although I have seen him, once or twice, distractedly herding the others into the car. Whether in the country or the city, you see men on barstools in the middle of the afternoon, men who might be forty-five or sixty-five, it hardly matters, nursing a beer, watching the TV.

For all I know, any of these men might have worked all night, or just finished a long construction job, or be actors or writers who work intense but irregular hours. But the point is not that they do or do not earn an honest day's pay or have wives or children to whom they're devoted so much as that they stand aside from the trappings of adulthood—the nine-to-five job, the business dress—although there is nothing childish, there is indeed something of an adult's ferocity, in their very insistence on doing as they please. Watteau, three hundred years ago, was the first artist to show us a world full of men who are animated by this understated masculinity, this held-in force. Artists are of course the great experts when it comes to such a potent yet equivocal way of dealing with life, turning all their intentness and sobriety inward, into the twists and turns of their craft, so that their offhand swagger, their gift for being entirely relaxed in the middle of the day, has a secret weight, a hidden gravitas. In New York in the 1950s these men gathered at the Cedar Tavern, and I still know a few painters, men who came up in the 1960s and 1970s, who have that mild intellectual swagger, who are masters at making painting seem like something for a bright, popular high school boy to get into, and who know the art in the museums, but know it offhandedly.

These men who stand at a certain distance from the nine-to-five world may find that distance difficult to maintain, however, for their self-confidence has a passive-aggressive ambiguity that can all too easily be overplayed. There can be something too princely, something snobbish about their

attitude toward the rest of the world, as if they've got everything figured out. A quiet masculine belligerence can turn into a crackpot belligerence, so that some men may have asserted their independence for so long that the assertion becomes its own lonely justification—a querulous gesture. The secret of pulling this off is that a man must turn his back on certain obligations with a certain elegance—with a kind of wink. At the Laundromat in a little town, I've seen an older man, still trim, his face lined from smoking, carefully folding his jeans and sheets and towels, and something in the shipshape efficiency of the way he organizes his clean clothes leaves me imagining that he was once in the navy or the merchant marine. There's something disturbing about his improvised domesticity, but something cozy as well, a sense of a life with its own curious shape, and who would really care to judge that, who can know how it feels from inside? He is as mysterious as one of Watteau's solitary musicians.

Modernist. Samuel Beckett was slim and elegant and athletic, a loyal friend who was at once sociable and shy, a ferociously hard worker who was somewhat guarded and secretive about his work, an austere comedian standing off to the side in the bohemian shenanigans of mid-twentieth-century Paris. There is something about Beckett's demeanor that suggests the diffident jokers in Watteau's *fêtes galantes*, a Mezzetin, forever singing his sad, funny song, so it's not surprising that Beckett did indeed admire Watteau.

Beckett was a great enthusiast of the visual arts, the list of artists who interested him is very long, and the impact of their work on his work has been a subject of considerable discussion. His taste in the visual arts does not fall into any clear pattern, and surely his interest in Watteau, expressed in a number of letters, will challenge students of Beckett's ascetic and tragic art, at least until they recognize that Watteau's work is saturated with those qualities, with a gravitas that lurks amid the featheriness. Indeed, once you have stumbled on Beckett's interest in Watteau, it may seem more and more significant, as if Beckett's protagonists, alternately clownish and tragic, were distant descendants of Watteau's cast of characters.

Beckett's interest in Watteau goes back to the 1930s, when he was traveling in Germany, immersing himself in the museums that contain some of Watteau's choicest canvases, and for a writer who would ultimately find his voice on the stage, Watteau's art had a special fascination. There is a sense in which every painting is a kind of stage, and Watteau explored this dimension of painting as thoroughly as any artist who ever lived, until the framedness of the painting, the forcefulness of the rectangle, was capable of sharpening, accenting, italicizing the meaning of the most casual human behavior. It was in writing to one of his closest friends, Thomas MacGreevy, who introduced Beckett to Joyce and would later become director of the National Gallery of Ireland, that Beckett zeroed in on his feelings about Watteau. And those feelings were often tumbled together with Beckett's impressions of another painter, William Butler Yeats's brother Jack, to whom Beckett

had also been introduced by MacGreevy. Beckett became a great friend of Jack Yeats, and a great admirer of his work. On several occasions Beckett wrote about Yeats's expressionist landscapes and figure studies, works that are acclaimed in Ireland although they have never been fully embraced anywhere else. Beckett owned a couple of Yeats's disturbing, vivid canvases, with their rough, rich surfaces, their suggestions of stormy weather somehow brightly illu-minated, as if Turneresque color symphonies had been given an expressionist attack.

One of the things that interested Beckett about landscape painting, and he often appears to be writing about Yeats and Watteau and landscape painting in a single sentence, was the question of whether the landscape had its own logic, a logic alien to human beings, or was somehow a reflection or echo or accompaniment to the figure. For Beckett, that question was not so much formal as psychological, a question of man's comfort or discomfort in the world. What fascinated Beckett in Jack Yeats's work was what he saw as an admis-sion or perhaps even an acceptance of the distance between the man and the environment, a distance that Beckett some-how saw in Watteau, too. There was, so Beckett believed, even in Watteau's hymns to love's ecstatic union, a tragic sense of the mismatch between the figure and the environ-ment. He referred to Watteau's figures as "mineral" in the end, which perhaps distanced them from the vegetal nature of the landscape. And he described "the heterogeneity of nature and the human denizens, the unalterable alienness of the 2 phenomena, the 2 solitudes, or the solitude and the loneliness, the loneliness in solitude, the impassable immen-

sity between the solitude that cannot quicken to loneliness and the loneliness that cannot lapse into solitude." For Beckett, Watteau's pastoral promise, the promise that men and women can feel at ease in the world, was inherently vexed. The figure and the landscape, the figure and the world, can never really be reconciled, no matter how much the rhythms of the trees and the hills and the clouds echo the entangled arms and legs of the lovers in *The Pilgrimage to the Isle of Cythera*. In all of this, you see Beckett's fascination with being in the world but not of it, with a communion that is not union, or at least not entirely. You see how much sense this interpretation of Watteau would have made to Beckett, a man at once sociable and shy, a man who frequented cafés but was extremely protective of his privacy. We travel to the isle of Cythera, but we never really feel at home there.

Let us think, therefore, of Beckett and Watteau as related. The men and the women in Beckett's plays, so clownish and so heartrending, so artificial and so real, can claim among their ancestors the Harlequins and Pierrots and assorted dreamers and schemers who take their places in Watteau's paintings and drawings. For both artists, the waiting, the questioning, the equivocating, the bafflement, the absurdity—this all adds up to a ritualization of perplexity that eases their anxiety.

Muscles. In *The Tragic Muse,* Henry James writes that "there is always held to be something engaging in the com-

bination of the muscular and the musing, the mildness of strength." The observation is made about a young man who wants to be a painter but is seen by many of the people around him as having great potential as a politician, and James obviously uses this mingling of the muscular and the musing to suggest the conflict between a life of action and a life of reflection, a conflict that is embodied in the tall, handsome figure of Nick Dormer. We see Nick in this relaxed pose at the beginning of the novel, in one of those scenes that James sets up as if it were a picture to be observed, with Nick and his mother and sister meeting various other people at an art exhibition in Paris, and indeed the combination of the muscular and the musing is essentially pictorial rather than literary, a cornerstone of classical art, going back to the athletes and heroes of Greek and Roman sculpture.

The visual arts are supremely equipped to express the possibility of action; they may well express it better than action itself. But in modern times a curious shift has occurred, and what has more and more interested artists is the impossibility of action, or if not that, then certainly the difficulty of action or the idea of action as forever delayed. You feel this in Degas, who although one of the great students of human movement, sometimes found himself representing the dancers who labored in the rehearsal studios or who waited in the wings of the theater as bodies that are not doing what they're meant to do, at least not now, at least not while we are watching them. And this immobility, which is perhaps largely a matter of naturalistic observation in Degas's work, becomes a philosophic theme in Picasso's

representations of jugglers and acrobats and other circus folk. It is as if Picasso were telling us that all the great narratives of Western art have ended, that these Harlequins and *saltimbanques*, although so physically strong and expertly trained, have been stopped in their tracks by the changing nature of art. Who can doubt that an art that in the Renaissance was grounded in the muscularity of the figure has been replaced, in modern times, by an art that is grounded in the musings of the imagination?

N

Nerval. Gérard de Nerval, in Nadar's famous photograph, has the scruffy, battered, exhausted, but still eager look that you often see among Parisian writers in the frantic years of the nineteenth century, when the reading public was exploding and books, pamphlets, magazines, broadsides were pouring out of the printers' shops, an inexhaustible torrent of opinion. In this photo taken not too long before he committed suicide in 1855, by hanging himself on a Parisian street one freezing night, Nerval has a pleading, beseeching look in his small dark eyes, and the flesh of his face is creased yet puffy, suggesting a man of an indeterminate age. He was in fact in his mid-forties at the time, veteran of a number of stays in sanatoriums in Paris, and yet in some respects he was only beginning to come into his own. In these last years of his life, Nerval was finally publishing books that were stamped with his whimsical, fantastical individuality. He was at long last making his impression amid the literary glut and literary hyperbole of mid-nineteenth-century Paris, an age of opinions and arguments, of roller-coaster reputations, a time when feeling, viewpoint, vantage point were more than ever pressed and pushed and emphasized and accented, from the cacophonous tirades of the characters in Balzac's vast novels to the

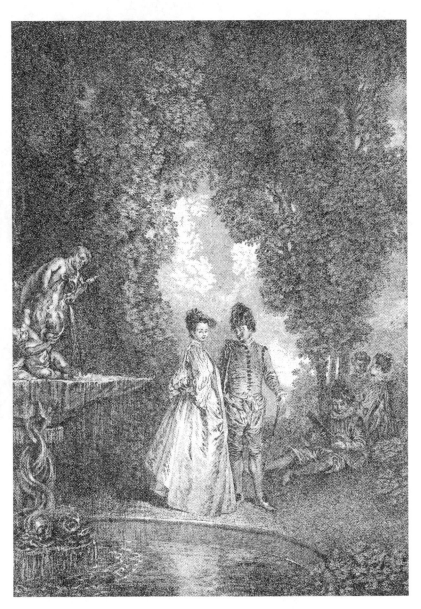

Print after Watteau, *The Cascade*

lonely voices of Baudelaire and Rimbaud. Even quietness, enigma, effacement, mystery became extravagant in this excitable atmosphere, which explains why so many writers were drawn to Watteau's supercharged delicacy. They discovered in his shadowy gardens and sweet figures and erotic games a glorious escape from the pressures of city life, an escape that is among the themes of Nerval's "Sylvie," which C sent to me, with the comment "It's a perfect piece of writing." And so it is, but of a most idiosyncratic variety.

This short story leaps through time; it's full of starts and stops. The protagonist, who is also the narrator, is a young Parisian, dabbling with playwriting, besotted by an actress whom he goes to see in the theater every night. He grew up not far from Paris, in what strikes him as a rural paradise, a paradise that he returns to in search of Sylvie and another girl, Adrienne, whose fair-haired beauty had diverted his attention from Sylvie once, long ago. The narrator's experiences in Paris and in the countryside are juxtaposed in such a way that at moments a reader isn't sure if he is hearing about the narrator's youth or his later attempts to revisit his youth. And the landscape through which the hero moves is itself somehow historically unstable, full of the ruins of ancient castles and churches, a jumble not only of Renaissance and medieval structures but even, so we are told, Druidic rock formations. It is as if in returning to his childhood this young man cannot be certain that he is not in fact imagining one of the romantic stage pictures that he's seen in the Paris where he now lives. At every turn, he falls down

one memory hole into another, and perhaps the strangest and most remarkable of all these scenes is one in which he and Sylvie go to visit a beloved old aunt of hers. And while the aunt cooks them a hearty country breakfast, they go up to her room, where she has sent Sylvie to look for some samples of old lace, which might serve as models for Sylvie, who is a lace maker.

In Sylvie's aunt's bedroom the narrator looks at a painted portrait in an oval frame, the old woman as a young woman, and explains that he is "reminded of the pantomimes at the Funambules," the pantomimes that Deburau, father and son, had created and that would later inspire *Children of Paradise*. In these pantomimes, so he explains, the fairies would hide behind wrinkled masks, only to reveal their lovely faces at the close, when the Temple of Love made its appearance. In Nerval's story, Sylvie and the narrator find themselves putting on what amounts to a theatrical for her aunt, reenacting a wedding of a generation earlier, removing the aunt's wrinkles, revealing her earlier self. In her chest they find the dress in which she was married so many years ago, along with the costume that the groom wore. And Sylvie puts on her aunt's old taffeta gown and pale pink stockings with green figure work, and the narrator puts on the gamekeeper's wedding outfit, and they are transformed into a bride and groom of another century, a pair of country lovers out of Watteau. And just as they've finished putting on the costumes, Sylvie's aunt tells them that breakfast is ready, and they hurry downstairs. They are "hand in hand," so the narrator recalls. "The aunt uttered a

cry as she turned around and saw us: 'Oh, my children!' she exclaimed, and began to weep, then smiled through her tears. It was the image of her youth—a cruel and charming apparition. We took our seats by her side, quite moved and almost solemn, then we all grew light-hearted again when, the first shock passed, the old lady began regaling us with memories of her elaborate wedding."

The art of Watteau is threaded through "Sylvie" and much of Nerval's other writing; it is a leitmotif or a subtext, invoked in the images of a slim girl dressed in the pink and green fabrics of another century, in the country dances, the parks with their ruined structures, but also invoked directly, as when Nerval titles one section "A Voyage to Cythera" and observes of an ancient but still enduring festival of the Knights of the Bow that the banquet with which the celebrations ended was held in a small pavilion after a "crossing of the lake [that] had perhaps been devised to recall Watteau's *Voyage to Cythera*. Our modern dress alone spoiled the illusion." Elsewhere, in another curious fiction, "Angélique," Nerval observes that Watteau's great painting "was conceived among the thin variegated mists of this region. His Cythera was modeled on one of the islets created by the flooding of the Oise and Aisne—these rivers which are so calm and so peaceful in the summer." According to Nerval, the landscape in Watteau's painting was based on the terrain and vegetation of this region near Paris. And Watteau's work, in turn, inspired some of the festivities held in the area, and shaped Nerval's apprehension of the place.

Now we know that nature inspires culture and that culture affects our understanding of nature. And perhaps the fascination of Watteau for Nerval—and for all of his ink-stained, harried, harassed literary brotherhood in Paris—was in how intensely knit together those exchanges became, as if the instinctual and the learned, intuition and reflection were joined together in a perpetual state of confusion and excitement, until Nerval was scarcely able to determine which was which. Nerval responds to a certain anxiety in Watteau, and it is this anxiety, woven deep into the painter's ambiguous theater, that Beckett will be thinking about a century later when he writes of "the heterogeneity of nature and the human denizens" in *The Pilgrimage to the Isle of Cythera.*

New. What is truly new in art is a strong emotional inflection, a personality imposing its fresh feelings on everything that appears resolved in the art of the past. These feelings must, of course, find their ultimate expression in some quality of form, and it may be only through the experimentation with the forms that the feelings become clear. But it is the indissoluble individualism of the artist that gives the work of art its staying power. Newness, in this sense, is grounded in the fact that each person is somehow unique. New, in the sense I am thinking of it, is not progressive or evolutionary but a continuous unfolding of images and ideas, so compelling in their individualism that their hold on the eye and the imagination retains its force, even after the artist is long

gone. The point is not, however, that the strongest or most unusual personality makes the strongest or most unusual art. The process is more elusive than that. It depends on a willingness to hand over one's emotions or feelings to the work of art, to allow one's personality to float away from one and lodge in form. It is with this peculiar process that impersonality comes into play, for the artist must be willing to allow the feelings to take on a life of their own, and perhaps more important for the artist than the particular character or quality of a feeling are the feelings about that feeling, an ease with one's feelings, an equanimity about one's feelings. All the artists of any consequence whom I've known have been to a certain degree detached from the emotional character of their work, as if this were some difficult feeling, some strange emotional weather that they had made their peace with, that they had allowed to take its place in the autonomous world of form.

New York City. Dime-store decadence, puerile yet sadistic, oozed out of *Behind the Watteau Picture,* a one-act verse play by a man named Robert Emmons Rogers, that was presented in November 1917 at the Greenwich Village Theater on New York City's Sheridan Square. The play was Greenwich Village bohemian claptrap, perhaps designed to scandalize the tourists slightly, a downtown goosing of the uptown or out-of-town audience, a dumb little sideshow on the road to the Roaring Twenties. The experimental theater was beginning to boom back then, and the

Greenwich Village Theater was a less distinguished relative of the little theaters flourishing below Fourteenth Street, which included the Neighborhood Playhouse, the Washington Square Players (which became the Theatre Guild), and most famous of all, the Provincetown Players. And if Eugene O'Neill stood at the zenith of this downtown modernity, *Behind the Watteau Picture* was probably close to its nadir. The drama was a curiosity, a last, sheepish gasp of the fin de siècle, a work of sentimental pornography, part *Salome*, part *Rite of Spring*, with Columbine, the heroine of the commedia dell'arte whose easygoing sensuousness Watteau gently embraced, now transformed into a man-eater whom the tall, tragic Pierrot somehow had the power to put to death, a power he couldn't finally bring himself to exercise, although her kiss could kill—almost literally, as we see. The play was a deflated decadent bauble, and in its published version it was advertised as something that "can be given by amateurs on a restricted stage"—something a little off the beaten track, a little daring, for the provincial theater group to take on. So here we are, in the sordid afterlife of Watteau's romantic vision.

Behind the Watteau Picture opens with a tableau suggesting Watteau redone by Maxfield Parrish—a Marquis and Marquise and Poet are posed before a tall garden gate, a statue on a pedestal to one side, a dusky sky, the whole tableau rather harshly outlined, more Art Deco than rococo. A fat Pierrot appears and warns them that the garden "'tis a deadly place," but the Marquis and Marquise and Poet can't resist sneaking in, whereupon they get a lot more

than they bargained for. A Harlequin and a retinue of Negroes and Chinamen (as they are described in the play) appear, the Negroes naked to the waist, scimitars at their sides, turbans on their heads, each carrying a shovel. "Who lives here?" the Marquis asks the fat Pierrot. To which the reply is "A strange, strange master! I believe he's called the Melancholy Pierrot." And soon, here he is, a tall, thin Pierrot, drawn and lean, with hollow dark eyes and a sardonic slash of scarlet for a mouth, absent and moody. At Harlequin's order a grave is begun, but not too deep a grave, for as he explains, "She who will sleep is very little, very frail and slim. To dig so deep were grim sardonic jest."

Eventually, the woman who is destined to be buried, almost buried alive, so it seems, appears. And she is none other than Columbine, that commedia dell'arte ingenue, but now pale, wild, anything but the benign shepherdess of countless winsome canvases. This dainty Columbine turns out to be a closet vamp, literally a killer, but so sweetly seductive that both the Marquis and the Poet fall under her spell. She kisses them, she tells them that she will dance with only one of them, and her kisses are so intoxicating that the Poet and the Marquis draw swords, attack each other, and are mortally wounded. And yet Columbine claims that the mayhem she causes is not her fault, that, so she explains, she "strove with love against the powers who fill this garden close with death." And Pierrot, who knows Columbine has to die, nevertheless can't bear to let her go, even when Harlequin reminds him that although she is "sweet to the taste" she is "rotten," rotten to the core. "You will not kill me

now?" she realizes, raising the triumphant question. "Too beautiful, too beautiful to die?" And indeed that is the case. So Pierrot orders the grave filled, for "she shall not die tonight." And Columbine is left to her strange musings, singing to nobody in particular, "Who will live to love me yet / After this bloody minuet?" And soon after that the curtain comes down.

What a strange sight this Columbine is, this Salome reimagined as a delicate piece of Dresden china—an absurdly leaden fantasy, smashed, a crock.

O

Ornament. "Monsieur!" (from a letter Watteau wrote to Jean de Jullienne in 1719) "When we were last together you asked my opinion of a painting by our young friend, Pater, who studied with me for a time. I know that I responded a little heatedly, complaining about the busyness of the composition, the bewildering excess of decorative accents. I'm depressed when I see how many artists are addicted to a hideous, common ornamental language, to the arbitrary arabesques, the trumped-up asymmetries, the vines entangled for no good reason on every fan, every snuff box. Poor Pater, he never seemed to understand a thing I told him. In my view, you must either do away with ornament—or make ornament the essence. It's not something you add. It's not icing on a cake. It's everything—or it's nothing. I know this; after all, I worked with Audran on those ornamental panels that you can see in so many drawing rooms. Such décor has its purposes. I believe I did it well. But a painting is another matter, and in a painting the lovely young woman must herself be an ornament to the world, her whole turning body must be one great, witty curve. Think of Titian, think of Leonardo, think of Raphael. Their paintings have almost no ornament, except for the glorious ornamental nature of the figure. And then

Print after a design by Watteau

remember that Leonardo and Raphael were masters of ornament: Raphael covered the halls of the Vatican with arabesques and grotesques; and just think of the cunningly entangled vines that Leonardo created for the King of France! Oh, they knew ornament, and knew that it has its own grandeur. Of course from time to time I have put the ornamental element into a painting—a statue, a clock, a portico. Well, there it is, I have said more than I imagined I would. A model is coming in a minute, and I must take up the red chalk again. I ask you to not forget me to Madame de Jullienne, whose hands I kiss. A. Watteau."

Detail from a print after Watteau, *The Perspective*

P

Party. Sometimes I find myself imagining Watteau and his tradition, the tradition from which he emerges as well as the artists who have been touched by his work, whether directly or indirectly, as an out-of-time-and-space variation on one of the painter's own garden vistas, a Parnassus where all the daydreamers meet. Giorgione, the mystery man of Venetian painting, with his emerald green views and silken lovers and handsome musicians, is here. Look over there, near the fountain, and you can see Bonnard, his face rather severe behind wire-rim glasses, thinking about painting the explosion of yellow flowers outside the window of his studio at Le Cannet, or his wife, Marthe, in the bathtub that is like a sarcophagus, a pastoral with intimations of death, a new variation on Poussin's *Et in Arcadia ego*. And here is Colette, with her hennaed hair and bare feet in leather sandals, who in her novel *Break of Day* imagines a love affair between an older woman and a younger man ending as a long night wanes in a beautiful house on the Côte d'Azur. But look at another part of the guest list and you will see that Watteau has invited all the artists and writers who love Pierrot and Harlequin. Callot, whose engravings of the commedia dell'arte have a sleek, sardonic vigor, has joined the festivities. And here, too, are the poets who

love the commedia, Verlaine, Laforgue, Apollinaire, and Wallace Stevens. And there is Schoenberg, with a little orchestra, preparing to perform *Pierrot Lunaire*. And here are the dancers who've immortalized Harlequin and Pierrot, Nijinsky, who starred as Harlequin in Fokine's *Carnaval*, and Edward Villella and Mikhail Baryshnikov, who both played Harlequin, his back to the audience as he serenaded his sweetheart, in Balanchine's *Harlequinade*. Rilke, who wrote about Picasso's *Saltimbanques*, is standing by himself. And Matisse, who painted some of the legendary pastorals of the early twentieth century, is rowing out into the middle of the lake, his strong arms and chest handling the oars with surprising ease, accompanied by a gorgeous young woman who's wearing the Harlequin dress, beautifully crafted, that he likes to have his models try on. And let us not forget Picasso, who has been telling dirty jokes with an overweight old Pierrot but has just gone out into the garden and joined some elegant young women on the grass, where they are all listening to a young classical guitarist, a handsome Spaniard with dark, almond-shaped eyes, the toast of Paris this season.

The Pilgrimage to the Isle of Cythera. The human mind is artless, elegant, clumsy, penetrating, chaotic, obscure, a hopeless mix of serenity and hysteria, the lofty and the low-down, clarity and murk, and Watteau pulls his drawings and paintings straight out of this messy material, these moment-to-moment shifts in perception, apprehen-

sion, and feeling. His paintings suggest a mind that is, like all our minds, at once self-indulgent, unreliable, relentless, lucid, obtuse, unruly. And like the rest of us he allows his thoughts to drift, his moods to shift, his focus to go out of focus. We've all woken up in the morning feeling blue and then, an hour later, unaccountably, felt cheerful. Or vice versa. We know what it means to be confounded by our own emotions. Watteau's working methods, so far as we can see, mingled long periods of meditation and periods of frantic labor. He was willing to fuss over small things and do big things quickly, and by utilizing this erratic approach, he somehow managed to transcribe the vagaries of the human mind onto canvas, giving the painting a psychological texture like nothing else in the history of art. We accept Watteau's opacities and obscurities because we know what it is like to find ourselves, in the midst of even the simplest task, thinking about something entirely different.

"Your soul is like a landscape," Verlaine wrote in one of his *Fêtes galantes,* the cycle of poems in which he reflects on Watteau's themes. And a soul and a landscape, the two becoming one, is an old story in the arts, beginning with the pastoral visions of the poets of ancient Greece and Rome. What a weight of feeling the pastoral landscape has absorbed, this landscape that is not seen directly so much as it is recalled, reconstructed through the mind of the poet or painter. It has been pointed out that what may at first strike us as the natural elements in pastoral poetry or landscape, such as the grove that contains many different types of trees, are not necessarily observed in nature but are to some

degree invented, a rearrangement based on the needs of the imagination. Only think of the landscapes on the walls of Roman villas, those meandering inventions, with shepherds, sheep, gods, heroes, temples, groves, springs, monuments, port cities, oceans, ships, all disposed willy-nilly, as apparently disorganized as our thought processes. These ancient frescoes are stream-of-consciousness paintings, cascades of images. And their effect can be deeply disquieting, for the little figures scattered here and there look lost, or at least humbled by the vastness of the natural world.

For Watteau, the tradition of the pastoral landscape, extending from the ancients to the Renaissance and Poussin and Rubens, suggests a painting that is all psychological texture. He embraces this great tradition as a map of the soul, the mind, the imagination. Watteau goes right ahead and plays with the elements, much as the ancients did. He arranges and rearranges the grove, the fountain, the lovers, the distant hills. The elements of the landscape painter's arsenal—sunshine and shade, the nearly opaque forest and the translucent aerial perspectives—are denaturalized, psychologized. He mingles the city people who are visiting the country with the shepherd and shepherdess who look awfully well dressed for real country folk. As Beckett observed, Watteau does not worry about establishing a perfect balance between the landscape and the figures. Indeed he risks a disharmony, a disquietude that becomes a reflection of the painter's vexatious state of mind. ("There's so much trouble everywhere these days," Virgil exclaimed in the first of his *Eclogues*.) Watteau's Gardens of Love are

artifices, sure enough, but they are constructed with an ease that lends their unabashed strategizing a naturalistic tingle.

Let us talk, then, about *The Pilgrimage to the Isle of Cythera*, nearly seven feet wide. This is Watteau's essay in pastoralism on the grand scale, his attempt to match the poetic ambitions of Poussin and Claude, but on his own terms. So it is a magnum opus knocked off as if it were a sketch, an epochal vagary, a symphony amid his chamber music, an oratorical tour de force whispered in a sympathetic ear, a hailstorm of feathers, a lightning bolt as gentle as a summer breeze. What we see when we first look at *The Pilgrimage* in the Louvre is a painting with great flowing movements, the rhythm of grassy foreground and distant hills creating two powerful undulating lines, like wave patterns. And amid this gentle maelstrom, Watteau sets a number of men and women and cupids, but especially three couples, the central actors. Their incomplete embraces and crisscrossed glances, which give such a lovely shape to disorderly experience, are the essence of Watteau's art. Something is known about the genesis of the painting—or paintings, more precisely. There are two versions, because after painting the grand, official composition, which is actually the more casual canvas, Watteau did a second version for a friend.

And here is the story. When Watteau was accepted as a member of the Royal Academy, in 1712, he had to paint a reception piece, the subject of which was left to his discretion, unusual for the Academy. Beginning in January 1714, the Academy repeatedly requested that Watteau submit the

Detail from a print after Watteau, *The Pilgrimage to the Isle of Cythera*

painting. But no painting was forthcoming. Then, in January 1717, the Academy gave him an ultimatum. He had six months. When the canvas was finally submitted, and accepted by the Academy on August 28, 1717, it was first recorded in the official record as *Le Pélerinage à l'isle de Cithère*, Cythera being a mythical Isle of Love that was spoken about by Plato. But then the title was crossed out and replaced with the simpler, perhaps less dangerously erotic, *Une Feste galante*. And so began the story of *The Pilgrimage to the Isle of Cythera*, this grandiose puzzle of a painting. The writing and the crossing out, the statement and the meander, so to speak, seem almost an inevitability with Watteau. And who can imagine that there would not have been problems, when Watteau, the man who practically invented the bohemian imagination, had set out to paint a composition that was an expression of the official mind, the mind of the academician? When the canvas was inventoried in 1775, by no less a figure than the still life painter Chardin, who was at that time an official of the Academy, it was called *An Embarkation for Cythera*. But is this an embarkation? Are they going to Cythera, the Isle of Love, these lovers who are accompanied by a cascade of cupids in a painting that contains what is all in all a large cast of characters for Watteau? Or have they already arrived? This is not a trivial matter. For the question is whether the three couples who are at the core of the composition, the men perhaps importuning, the women perhaps reluctant, are in the process of falling in love, or are looking forward to actually making love, or are seen in the aftermath of love, reflecting

on the experience. The first title, *The Pilgrimage to the Isle of Cythera*, leaves the possibilities open, leaves us uncertain as to at what point we are on the pilgrimage, as to where we are in love's trajectory. And Watteau's admirers have debated ever since.

One might say that the theme of this great painting is a rather simple question—Are you coming or going?—a question that runs through pastoral poetry, where the shepherds and farmers are sometimes losing their land, or yearning to return to it, or the city folk are just visiting, and who knows for how long? Yet this absolutely ordinary question—Are you coming or going?—the question we've all asked a friend as we arrive at a party, is raised to the level of metaphysics by Watteau, or at least is given all the allegorical trappings, but lightly, so they do not become a trap. The mind of the academician yearns for clarity, grandeur, while the mind of the bohemian wants to foment mysteries, and in *The Pilgrimage* the two minds are at work together, or at work in the same place. Perhaps it is Watteau's idea that all painting is this mingling of the clear and the unclear, the definite and the vague, as confused, as many-sided as the vexatious imagination itself.

While I was thinking about all of this, a friend who has written his own version of the pastoral poem, a poem called "Astropastoral," wrote to me, reflecting that the pastoral has "a non-Romantic, non-Christian sense of limits, human limits, natural limits, god's limits." And I suppose you feel this when you look at those lovers of Watteau's, who have embraced, or will embrace but are not now necessarily

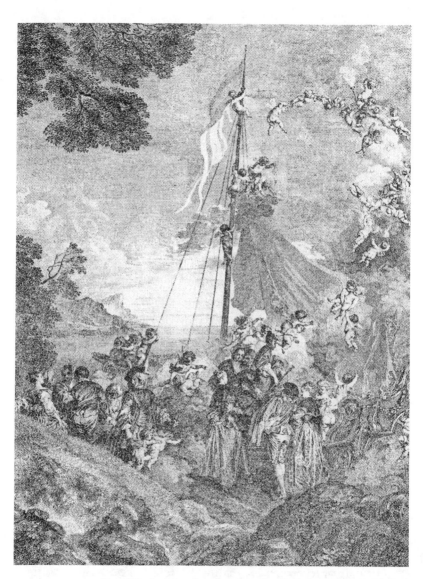

Detail from a print after Watteau, *The Pilgrimage to the Isle of Cythera*

embracing, those lovers who, although they look so lovely in this landscape, do not quite belong, as Beckett has observed. Watteau was among the first moderns to make the pastoral as ambiguous as it was for the ancients. This is not a neat neoclassical place, with everything nicely sorted out, but a place where conflicting forces, desires, passions are in play. This is the drama that one knows from Theocritus or Virgil, of people who are consumed with their own dramas, the dramas of the present, the drama of wondering who they are, what they will do with the person next to them, what they want, what they can get.

Now all of this makes the painting sound sad, maybe even tragic. Which of course it is not. Yet there is a confusion of moods. This is reflected in the ecstatic description of *The Pilgrimage* by Edmond and Jules de Goncourt, the nineteenth-century brothers who did so much to revive interest in Watteau, and who pulled out all the stops in describing this painting, which was the first of Watteau's works to hang in the Louvre, and indeed the only one to hang there through much of the nineteenth century. "Beneath a sky painted with the colors of summer," they wrote, "the galley of Cleopatra sways at the water's edge. The tides are dead; the woods are silent. From the grassy earth to the heavens, beating the breathless air with their butterfly wings, a swarm of cupids flies, flutters, dances, frolics, now joining with a knot of roses some too indifferent pair of lovers, now sealing with love knots the round of kisses that floats up into the sky. Here is the temple, the spiritual destination of this world: the painter's *Amour paisible*,

Love disarmed, seated in the shade, the Love whose image the poet of Teos would have engraved upon some vernal drinking cup; it is a smiling Arcady, a tender Decameron, a sentimental meditation; caresses are dreamily exchanged, words lull the spirit; there is a pervasive atmosphere of platonic affection, of leisure preoccupied with love, of youthful, elegant indolence; the press of passionate thoughts composes, as it were, a ceremonial court of courtship"— and so the two brothers go, on and on and on, leaping from Plato to the *Decameron* in a delirium of happiness. And if the Goncourts seem determined to have love every which way in *The Pilgrimage*, who can blame them, for it is a painting that will not sit still, a painting in which we do not know if we are coming or going, we do not know if we are hoping that something will happen or talking quietly about something that has already happened. It's elegant chaos— a painting, in short, as vexed as the mind itself.

Postcard. For a long time, L had in his office a postcard of the tiny, magnificent nude by Watteau that is in the Norton Simon Museum in Pasadena, the nude with the perfect breasts, who is reclining in her bed, who is turning to look at her own behind. The painting is actually a fragment of a larger work; a drawing that may represent the full composition survives. In the eighteenth century there was very likely a second figure in the painting, a servant administering an enema, so that the naked woman's turning head told a story—she was turning to watch the servant at work on

the far side of the bed. It has also been suggested that the second figure was not a female servant but a naked youth mentioned in an account of a lost Watteau. In any event, the painting surely exuded a complicated erotic heat, and even now, though the canvas is in certain respects a ruin, the heat remains. As for the postcard in L's office, I remember it was casually leaning on a bookshelf behind a couch, books heaped on the couch, books piled on the floor, books stuffed into the bookshelf, while Watteau's woman contemplated herself in perpetuity, surely ignored by most of L's visitors.

Q

Qualities. Yes, of course, I am excited by the totally integrated work of art. But the truth is that there is something far more important to me than this unitary idea, than this emphasis on quality as the achievement of wholeness and consistency and perfection. What I really want from art is a variety of qualities, a multiplicity of qualities, a kaleidoscope of qualities, the unpredictability of qualities, qualities that are as varied as the artists who create the works of art. And I suspect that when artists are shaping and deepening and clarifying the qualities that mean the most to them, then quality in the sense of wholeness and oneness takes care of itself.

Questions. There are certain artists who see a work of art as a puzzle that can never be entirely resolved, so that a painting becomes an essay in uncertainty, the crystallization of a question. That an artist might consciously cultivate ambiguity was an idea that had already occurred to Vasari, who in writing the life of the Venetian painter Giorgione in the middle of the sixteenth century was confronted with the strange fact that nobody in Venice seemed able to explain the subjects of Giorgione's frescoes in the Fondaco dei

Tedeschi, a warehouse complex. "I have never been able to understand his figures," Vasari wrote, "nor, for all my asking, have I ever found anyone who does." All that seemed to matter to the Venetians was that Giorgione's figures were beautifully painted. And the issue that Vasari first raised, this matter of the irresolution of meaning, echoes all the way down to Rilke's famous question in the *Duino Elegies*, written while looking at *The Family of Saltimbanques*, a masterpiece of Picasso's Rose Period, "But tell me, who are they, these wanderers, even more transient than we ourselves?"

The ambiguity of meaning, the idea of the questioning of meaning as a new form of meaning, is a tradition, a dissident tradition, that runs through the art of Europe, and of other places as well. This is not a clearly delineated tradition. How could it be? It is an undercurrent, an anxiety, a disquietude, threaded through European art, communicated from one artist to another, from Leonardo to Giorgione to Watteau to Corot to Picasso, but almost secretly, so that we are often at a loss as to how to make the connections. This continual raising of questions is not without some sort of meaning, indeed it is almost too fraught with meaning, almost bursting with meaning, with multiplying meanings, meanings that may be at cross-purposes, oddly mismatched, strangely juxtaposed. Late in life, Corot completed a small group of haunting forest scenes in which a horseman or a mother and a child are wandering almost aimlessly at the end of a beautiful day. In these extraordinary works, the curious relationship between the small figures and the vast trees, the weight of the figures contrasted

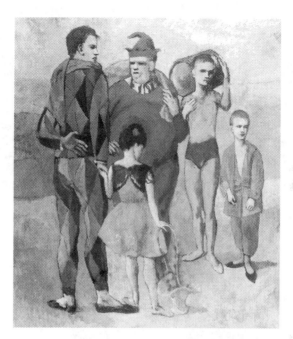

Detail from Pablo Picasso, *The Family of Saltimbanques*
(oil on canvas) © 2008 Estate of Pablo Picasso / Artists
Rights Society (ARS), NY

with the lightness of the trees—all this suggests the difficulty of ever feeling entirely at ease in the world and, perhaps, the pleasures of uneasiness, the almost sensuous excitement that can sometimes accompany a feeling of doubt. Who are they? Who are we? The questions are themselves the substance. The primal facts—man, woman, nature, culture—are always being questioned in the work of Leonardo, Giorgione, Watteau, Corot, and Picasso. Iconography yields to psychology. The primal becomes personal, but of course for the individual, what is more primal than the personal?

Print after Watteau, *The Holy Family*

R

Religion. To his nineteenth-century admirers, Watteau was the prophet of a new religion, the religion of art, and we do surely feel, when we look at his greatest paintings, that he wanted to give his deliciously personal subjects a weight, a gravitas that in the past had more often than not been associated with religious themes. Of course it is true that in Watteau's art specifically religious feelings are largely, although not entirely, absent, but they are present, in some sense, as an echo, an afterglow, a fading image on an old wall, something he could cast into the shade without entirely casting aside. In one of the rare religious paintings that survives, a Holy Family, the atmosphere is somewhat unstable, both frolicsome and agitated, with the Christ child playing with a white dove, his Mother smiling while she holds him, and Joseph in the background. Old auction catalogs document other religious paintings, now lost. The biographers tell us that at the time of his death Watteau was painting a crucifix for the priest of the parish church in Nogent. And *Les Figures de différents caractères* includes a number of religious subjects, a St. Jerome in the Wilderness, and studies of young monks, reading or praying out-of-doors.

Although it is not easy to say what the significance

of these themes was for Watteau, the art historian Max Raphael has made some striking observations about Watteau and religion, in an essay that appeared in 1933 in the first issue of the Surrealist magazine *Minotaure*. Raphael wrote that in *The Pilgrimage to the Isle of Cythera* and the *Gilles* we find "the conclusion of Christian ideas, the one as comedy, the other as tragedy." These works, according to Raphael, represent the final "materialization of Christian spirituality. God and the heavenly angels have become the gardens, the erotic figures, the silk and the satin." In part, Raphael is saying that Watteau gives the secular the same weight as was once given to the sacred, and that is surely one key to his genius. But if this is indeed the case, then how does it actually work, what is it that Watteau is doing? Certainly, in *The Holy Family* he is giving an admiring backward glance to the serpentine, pyramidal compositions of earlier, Renaissance and Baroque treatments of the sacred group. And we cannot say if certain religious subjects interested Watteau in and of themselves, or if it was simply that he could not be entirely indifferent to these subjects that had posed such a challenge to the artists who meant the most to him—to Rubens, surely, and to Titian and Leonardo as well. Perhaps when Watteau sketched St. Jerome in the Wilderness, a subject that occasioned some of the most darkly colored of all Titian's pastoral visions, Watteau was thinking not so much of St. Jerome but more generally of what it meant for a person in an extreme emotional state to be alone in nature, which would mean that elements of Titian's St. Jeromes, with their

burning embers tones, are in the prehistory of Watteau's pastorals.

What we are seeing at work here may be a subsuming or enfolding of certain kinds of feeling that had originally been associated with religious feelings into the radically different intensities of the secular. If this is true, then Watteau is among the first artists to live in the shadow world of the sacred, where religious themes are now metaphors, extraordinarily potent metaphors. Some have felt this power in the loaves and the glasses of wine that Chardin painted a generation after Watteau's death, for the bread and the wine might indeed suggest holy communion. Two centuries later, in Bonnard's paintings of Marthe in the bath, the nude nearly submerged in the tub has some of the gravitas of a baptism. And the bathtub itself, as deep and wide as a sarcophagus, can suggest an entombment. Of course to state these connections may be to push them too hard—to sentimentalize the undertones. The point is not that secular life can be as sacred as the old sacred life but that it partakes of some of the old weight, shape, and force.

The sacred images do not vanish so much as they transmogrify, as Dora Panofsky argued in a controversial essay on Watteau's *Gilles,* where she saw afterimages of one of Rembrandt's representations of Christ, or as a friend suggested late one night in his living room in Washington, when we were talking about Watteau's backs and he was reminded of Moses's encounter with God, whom he could only see from behind. Watteau loved the old forms, and it is the genius of his modernity that it always contained

something antediluvian, a memory trace of gods and god-desses, of the pagan and the Christian. Perhaps Watteau's various direct experiments with pagan and Christian subjects were a way of testing this process, of reconstructing the memories so that the memory would remain strong. When we think that two of Watteau's most important late works were the *Shopsign* and a crucifix, now lost, it is indeed as if he were ending in the most extreme dialectical spirit, painting his great scene from modern life, in which he anticipates Chardin, Courbet, and Manet—and then, soon after, this lost crucifix, in which he looks back to the sacred realm, to Van Eyck and Rubens and the entire Renaissance.

And what of this crucifix about which we know nothing except that it was painted for the parish church in Nogent, because Watteau did not like the one that was already there? I imagine a painting in silvery grays, with a glimpse of landscape at the bottom and Watteau's feathery trees gone wintry, skeletal, ghostlike. And a slim, austere Christ, a physique more like that of the adolescent, almost childlike Paris in *The Judgment of Paris* than the broad-shouldered, powerfully muscled Jupiter in *Jupiter and Antiope*. I imagine a crucifix related to the subdued, almost chivalric gravitas of early Renaissance painting in Flanders and Siena, at least something closer to that spirit than to the vehemence of Rubens, although considering how much Watteau owed to Rubens, it is unimaginable that there would not have been something of Rubens's physicality in this Christ, but a leaner muscular energy. And as for the religious feeling in this last work, I cannot imagine that Watteau, who only got

better as he went along, would not have met the challenge. I would think that the spirituality of this crucifix would have registered through the audacity of Watteau's painterly directness. Could there be a greater loss than this painting? For I suspect that Watteau opened up an entire world here—a new kind of religious art, in which the rendering of Christ's death became scrupulously personal, with Watteau laboring to finish this last avowal at a moment when he knew all there was to know about how it felt to be a man too young to die who was facing death.

Rococo. The baroque was an earthquake in Western art. The whiplash curves, the boisterously unstable ovals, the diabolically decisive diagonals, and the theatrical shadow play of Bernini, Caravaggio, and Borromini set off tidal waves that overwhelmed much of Europe and eventually spent themselves in the ocean spray of the rococo. The rococo, however, embodied no one look, no single style, for it all depended on where the wave had hit, so that you find the rococo spirit rippling through the comic figures in Hogarth's cycle of paintings *A Rake's Progress*, becoming feverishly extravagant in the gilded decor of churches in Spain and Portugal and their colonies in the New World, turning flirtatiously Olympian in the extravagantly cloud-scattered ceilings that Tiepolo painted in Austria, achieving a democratic yet aristocratic restraint in the elegant white plaster interiors of Dublin town houses, and taking on a sneaky classical wit in the wooden shop façades on Parisian

streets. The rococo was a physical impulse, an athletic inflection, energetic and fervent yet with an undertone of weariness and exhaustion, what Cyril Connolly, in the essay "In Quest of Rococo," called "a lyrical conception of humanity, a response to all that is transitory and fugacious, a calligraphy of farewell."

S

Sitwells. For decades the Sitwell siblings, Osbert and Edith and Sacheverell, were a unique, three-headed, walking, talking publicity machine. Their moments of greatest renown often came when Edith went before the public with *Façade,* her personal harlequinade, a set of poems that she (and others) declaimed through a huge megaphone, known as the Sengerphone, against the backdrop of William Walton's twinkling, whirling orchestrations. Edith's verses, with their vermilion pavilions and gilded trellises, "Mock Time that flies," but the main attraction was probably Edith herself, a freakish young spinster when she first performed *Façade* in a full public performance in June 1923, and later on, a perversely overaged Pierrot, at once pathetic and aristocratic, a shriveled sacred monster. By the time she died in 1964, Edith was an English institution, the Proustian underbelly of the soon-to-emerge Swingin' London.

All in all, the Sitwells were a strange lot. The long, pale faces, the hooded eyes, the thin, pointed noses, all characteristics of a desiccated European aristocracy, somehow underscored their self-appointed roles as the priestess and priests of a Janus-faced modernity. They understood, instinctively, that the unreality of the baroque and rococo painters, their interest in the construction of a picture as a

Print after a design by Watteau

sort of intellectual exercise, might be said to prefigure the self-consciousness of the Cubists. They saw in the gorgeously arabesqued surfaces of the rococo a prologue to the planar fantasies and the point-and-line-to-plane capriccios of abstract art. And so they created, as the poet Louise Bogan said of Edith, a world where "the sea and clouds move, but as by a set of levers, and soft living things become wood, gold, and lacquer." It was "a switchback world, peopled by personages called up from a mechanical commedia dell'arte." This was a modernity where, as in some of Sacheverell's books, you could move effortlessly from Watteau to Buster Keaton and from Shakespeare to Utamaro. If you only blow the dust off Sacheverell's yellowing pages, you will find remarkable things, such as a section in *For Want of a Golden City* on "noble rot," *pourriture noble*, an idea that Sacheverell borrowed from the world of wine and then used to describe a certain quality in art, something "picaresque" or "tatterdemalion" or "hypersensitive" that he found in Picasso's Rose Period, Rembrandt's beggars . . . and also in Watteau's *Gilles*. This was a modernity packed with allusions to the commedia dell'arte, the pastoral, the baroque, and the rococo—a sort of baroque meets modern harlequinade.

But what is a harlequinade? Strictly speaking, it is a theater piece starring Harlequin, that most stylized of comic figures, a figure armored in his stylizations who endures various hardships and travails but gets the girl in the end. In 1916, however, when Edith and Osbert published a collection of poems called *Twentieth Century Harlequinade*, they

surely meant harlequinade in some broader sense—as suggesting that modernity was a comedy of styles, that the modern artist might be juggling an array of styles and stylizations as intricately amusing as Harlequin's diamond-splashed costume.

Soldiers. Watteau's studies of military men are among his strangest works, a cold wind blowing through the warm spring afternoon of his art. Surely these compositions, which represent soldiers not in the midst of the conflict but in the preparations for battle or in its aftermath, are a surprise, coming as they do from the workroom of this great painter of amorous experience. Created relatively early in his career, around 1710, when the French were in the midst of the War of the Spanish Succession, these drawings and paintings can be dismissed as experiments in an understated realism for which Watteau had no natural gift. And yet the more that I look at these works, the more they strike me as being an integral part of Watteau's achievement. If we agree that many of his finest studies of love are concerned with the extent to which immobilization or indecision or ambiguity plays a role in human relations, then who can wonder that when Watteau painted soldiers he was exploring some of the same themes, only in the context of the upheavals of war?

In the fall of 1709 and winter of 1710, when Watteau spent time back in Valenciennes, the town was full of soldiers who had retreated there after the battle of Malplaquet, where the French suffered disastrous losses. Although it is not clear whether Watteau actually painted any of his mili-

Print after a drawing by Watteau

tary canvases in Valenciennes, he surely drew the soldiers
that he saw there, impressive figures with flaring coats and
tricorn hats. When he was studying these military cos-
tumes, he was as attentive to the dramatic angle at which a
soldier carried a musket as, later on, he would be to the way
a young woman brandished a fan. These studies of soldiers
were among the first of Watteau's explorations of the roles
that people play in life. And just as in his mature paintings
the actors are likely to be out of work and the lovers are
having trouble getting down to the business of making love,

so in Watteau's paintings of military life the battle itself is somewhere in the distance—an experience that is in the past or in the future, to be contemplated or feared. Watteau's soldiers, like his actors and his lovers, are at least to some degree detached from what might be said to be their actual function, although he is utterly clear-eyed about the price that war exacts, showing the wounds and exhaustion and confusion and aimlessness that surround the hours of pitched battle.

The atmosphere in these paintings, despite the delicacy of Watteau's hand, is grim and gritty, with steely skies. In one tiny painting, representing an encampment, a great tent has been hung from the delicately twisting branches of several fine trees. Soldiers are resting on the ground, their muskets helter-skelter, while other soldiers sit at a crude table with some of the women who have followed their menfolk. This is one of the last military works Watteau painted, perhaps around 1712. The scene, with baskets of food here and there and a drum casually slung over one soldier's shoulder, suggests a darkening pastoral world, the lovely land invaded, the shepherds become warriors, the lovers' grove become a soldiers' bivouac, a counterpastoral.

Watteau always enjoyed drawing and painting men and women reclining, close to the earth, animals restlessly at rest. The women whom he drew as they relaxed on his studio floor, who almost seem to be crawling, their slender arms outstretched, their long skirts awry, are diabolically elegant beasts. But then so, in their own way, are the soldiers whom Watteau observed in these dirty encampments, collapsed on the ground, heads in hands, dreamy, dreary, exhausted, bored, maybe bored out of their minds. If the

Detail from a print after Watteau, *The Respite from War*

women in the studio are waiting to make love—well, the
soldiers are waiting to make war, although the women who
have come along to the encampments would surely like the
men to make love, too, and the men are glad that the women
are here. It is the young men of the world who not only
make love most ardently but also go to war most frequently,
and indeed Watteau's scenes of military life, like his greatest
love fests, are studies in the promises and possibilities and
impossibilities of youth. Edgar Munhall, in a beautiful essay

devoted to *Portal of Valenciennes,* a military painting in the Frick Collection in New York, observes that "Watteau seemed fervently intent on capturing before it was too late the beauty of soldiers, with their fine profiles and well-turned calves, their graceful movements and haunting poses asleep, the elegant swing of their coats, the jaunty dips of their muskets. . . . Could his picture not be a depiction of young men likely soon to die, and specifically to die at the behest of their aged monarch?"

Watteau's soldiers are young men who have taken on a role, as in an infinitely more playful way they've taken on a role in his later paintings, whether of Harlequin or Pierrot. From being anybody or nobody, they have become a certain kind of somebody, they have put on costumes, they have prepared to go onto the stage that is a battle, the theater of war. And they may pay with their lives, which can hardly be said to be the case in Watteau's later art, where everybody has dressed for the battles of love, and the wounds and the deaths, however sharply felt, will not actually cause many people to bleed. Yet it may be that as Watteau watched the soldiers in Valenciennes, who were thinking of the battles that they had survived and looking ahead to the ones that they might not, he was learning things about boredom, hope, disenchantment, fear, passion, and persistence that would enrich the battles of love, which were to become his essential subject in the next few years.

Structure. She spent a month in a tiny apartment in Montmartre, the kitchen the size of a closet, with a stove

and a sink but no refrigerator, which didn't really matter because it was January and the milk could sit out on the window ledge. Each day, after making up the bed that was little more than a mattress on the floor, she went to the Louvre to draw. And once she was there and had checked her coat and her umbrella, for it rained much of that month, she hurried past the great nineteenth-century canvases on which the Romantics and the Classicists had waged their battles, making her way deep into the museum, to galleries where the crowds of tourists became a mere trickle, to the galleries that contained the hieratic images of Byzantium and the daringly stylized statues of the Romanesque.

How she loved the bluntness of the Romanesque Madonnas, loved their fierce, fearless frontality and their forceful, elemental gestures. She felt a special affinity with the art that had been produced in the centuries between the end of the classical world and the beginning of the Renaissance, when an elaborate illusionism had been rejected in favor of a bold simplification of nature, so that figures and landscapes and gestures and narratives achieved a hyperbolic power. Her mind was full of Byzantine and Early Christian and Romanesque art. Years earlier, she had lingered over the vast mosaic mural of the Madonna and Child in the ancient church at Torcello, a church which figures prominently in Ruskin's *Stones of Venice;* she had been fascinated by the Creation embroidery preserved in Gerona, north of Barcelona, with its circular composition and emblematic images radiating outward like the spokes of a wheel; and she adored the carved capitals in cathedrals and churches and cloisters in so many French towns, charming towns and

hideous towns, towns overrun with tourists and others where you could be alone with the curious images of saints and animals. She knew all of these strange and magnificent images as if they were the lines in her own hands, and they were very much with her as she spent those rainy January days drawing in the Louvre, drawing the figures and vegetal designs on Coptic textiles and Romanesque ivories, fragments of carved capitals, bits of mosaic, works full of fantastical stylizations, beguiling geometries, a world whose power had to do with the sense that everything— man, nature, even God—was ceaselessly reconciled to the primal plane of stone or wood or mosaic or cloth. It was a feast of simplification and idealization, a rejection of finicky realism, as wonderfully unlike quotidian experience as that little apartment in Montmartre was unlike her life back in New York.

And in the midst of this orgy of antinaturalism, she also found herself attracted to Byzantium's opposite, she found herself making a drawing of Watteau's *Judgment of Paris*. She focused on the figure of Venus, seen from the back, and that naked figure became the hidden face not only of the opulently dressed Byzantine visions that had beguiled her years before in Ravenna but also of all the Madonnas that had held her, rapt, in the silvery gray light of the French Romanesque churches. It was as if Watteau had exposed the great spinal structure, the steely yet sensuous feminine backbone, that supported the dazzling façade of Madonna, queen, and goddess alike.

Watteau, *The Judgment of Paris* (oil on canvas)

Detail from a print after Watteau, *The Pleasures of the Ball*

Time. Painting stops time—at least it stops time as we know time in our day-to-day lives. Within the delimited world of a painting, the forward flow of time is confounded, for even as the painter creates locations, intervals, and trajectories that hold our attention—that take our time—we nevertheless enter a realm where we can go as we please, where how much time we spend is for us to determine. In looking at paintings, we look quickly or slowly, we look where we want to when we want to, we enter into a time that is out of time. Even if the painter wants us to explore the canvas, say, from left to right, and regards that exploration as suggesting a spatial progression that is also a temporal progression, we are still free to regard left and right as existing simultaneously, or to explore not only from left to right but also from right to left—which might suggest going backward in time. If painting is one of the bellwethers of modernity—and who can doubt that it is?—this is surely because the painter, in shattering the orderly flow of time, offers such an acute sense of open-ended discovery, a sense of the canvas as a world through which we make our own way, a world in which we determine our own orientation, our own direction, our own sense of things.

Transformation. For years now, I've been accumulating material related to Watteau, either directly or indirectly, anything from articles and books to prints and postcards and cartoons. Sometimes, I have almost had the feeling that a mysterious force has put me in the right place at the right time, as when I walked into a used bookstore on East Twelfth Street and there, sitting on the counter, was a cardboard box labeled "Watteau Prints." Of course I bought everything in it, more than two dozen plates from *Les Figures de différents caractères,* for five dollars each.

The stories don't always have such happy endings, and there is one print, which I saw years ago at an antiques store but hesitated to buy, that has haunted me ever since. It was an etching of a commedia dell'arte group in an old gold-leaf frame, and Steve, the former actor who ran Steve's Antiques, wanted a hundred dollars for it. He had surely pulled it out of one of those decrepit Upper West Side apartments where somebody had died and the relatives didn't know what to do with all the old junk; Steve was friends with all the superintendents in the neighborhood, and got great stuff through them. But for a few days I hesitated about that print—I just didn't have the hundred dollars—and when I finally decided to buy it anyway, it was gone. Now I can't quite remember exactly what that etching looked like, but over the years I've fantasized that it was in fact an impression of an exceedingly rare print by Watteau, although it is far more likely that what Steve had was an impression of one of the eighteenth-century copies of that print. I can't be sure, perhaps this is all a hallucination, per-

haps the print at Steve's Antiques had nothing to do with Watteau. In any event, I will never know.

The most touching of all my Watteau finds is something far humbler, an advertising card for Chocolat Guérin-Boutron, probably produced in the late nineteenth century, which I pulled out of a box of miscellaneous papers at a flea market maybe twenty years ago. This is in the form known as a transformation, constructed of two pieces of printed paper, one of which slides over the other, in such a way that when you first look at the card, with its black-and-white reproduction and green type and curving, slightly Art Nouveau edges, you see a reproduction of *Gilles*—only to find, when you push the paper tab upward, that *Gilles* is overtaken by a portrait of Watteau. Somebody must know whether this card is part of a series of advertising cards in the same format that included painters and their works. That would be likely, as advertising cards tended to be produced in series, as something to collect. But the librarians I've spoken to don't have an answer, and for my own purposes the history of Chocolat Guérin-Boutron advertising cards is not of that much importance. I'm content to regard this card as part of the ever-widening circles that I can draw around Watteau.

Here, in the form of a popular advertisement, a sort of toy, we have a recapitulation of one of the most enduring myths about Watteau, namely that he is indeed Gilles, the melancholy or befuddled clown, that Watteau and Gilles are one, an idea that we are now told has no basis in fact but that was widely accepted in the late nineteenth century,

CHOCOLAT GUÉRIN-BOUTRON

GUÉRIN BOUTRON

GUÉRIN BOUTRON

WATTEAU
ANTOINE
Artiste Peintre
Né à Valenciennes en 1684, m. à Nogent en 1721
Élève
DE GILLOT

Édité par la Maison Guérin-Boutron

VOYAGE A CYTHÈRE id,
LE FAUX PAS id,
ENSEIGNE DE GUERSAINT id,
etc., etc.

Advertising card for Chocolat Guérin-Boutron

when this odd bit of ephemera was probably produced. I hardly care that Gilles almost certainly represents an actor who was a friend of Watteau's, for who can doubt that there is something poetically right in the message of this piece

of advertising kitsch, namely that Gilles is Watteau and Watteau is Gilles, that the great artist and the cow-eyed clown are one and the same. I can easily imagine Watteau announcing, "I am Gilles," much as Flaubert said, "I am Madame Bovary."

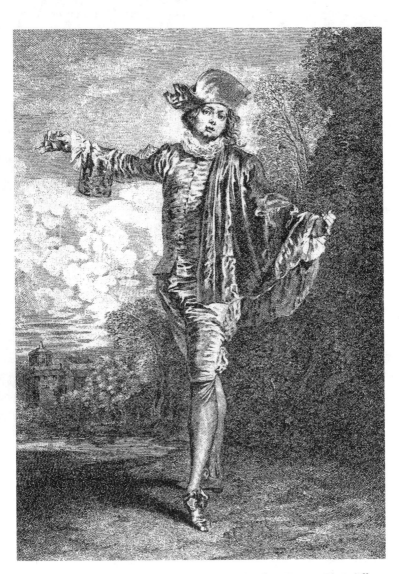

Print after Watteau, *The Indifferent*

U

Unconsciousness. Art is the conscious design of emotions that work on us unconsciously, an achievement of naturalness through the most unnatural of means. The painter with his brushes, his pigments, his oils, his canvas is engaged in an exacting alchemy, nurturing spontaneity and surprise even as he calibrates the risks, the possibilities. For artists, this paradox of the conscious design of unconscious feelings is the agony of their work, for artlessness necessitates the most exacting art and incalculable beauty can be achieved only through close calculation. It is no wonder, then, that there is so often something deeply neurotic about the act of creation, that a fierce struggle must be waged between the intelligence and the imagination. The strange fact is that inspiration must be crafted, that the flight of fancy must be engineered.

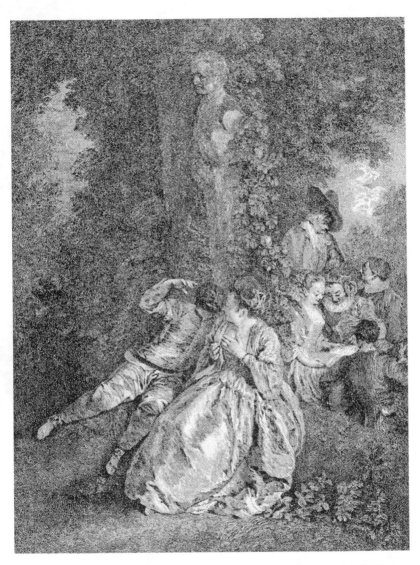

Detail from a print after a painting by Watteau

V

Van Vechten. Carl Van Vechten—author, photographer, chronicler of the Harlem Renaissance—writes in *Peter Whiffle: His Life and Work* about his first evening in Paris in 1907, when "even the buses assumed the appearance of gorgeous chariots, bearing perfumed Watteauesque ladies on their journey to Cythera."

Verlaine. *Fêtes galantes,* the book of poems on Watteau's themes that Paul Verlaine published in 1869, early in his career, has a quickening, sardonic charm. Verlaine is infatuated with Watteau's world, but this is not a woozy or sugar-coated infatuation, and the poet is glad to remind us, in "Les Ingénus," that the young women in Watteau's paintings might well be getting bug bites on their pretty necks as they linger in those summer gardens. Sex, Verlaine suggests, is not all flirtation and elegiacs; even the monkey in "Cortège" is thinking about what he could do to a beautiful pair of breasts. (Picasso copied this poem into a sketchbook when he was a young man.) And as for a pretty woman's coquetries, on which Watteau lavishes all his artistry, according to Verlaine they are sometimes rather like the performance of a pampered parrot. Yet Verlaine's *Fêtes*

galantes, for all its brisk mockery of the conventions of the *fête galante,* is not the anti–*fête galante* but more precisely a return to the true spirit of Watteau—quick, abrupt, gentle, ironic, songlike, all the more beguiling because the poet sets life's complexities and paradoxes in plain sight.

Vignette. Watteau was among the first masters, perhaps the very first master, who dissented from the dream of completeness that had obsessed the artists of the Renaissance and the Baroque. Although he saluted the idea of the definitive masterpiece at least once or twice, surely in *The Pilgrimage* and perhaps in the *Shopsign,* he generally shied away from the composition that aimed to contain an entire world or tell a whole story. His refusal to plan his pictures before he began to paint, a refusal that his friends saw reflected in his utter indifference to the sort of preparatory compositional study that the Academy regarded as essential, was a way of declaring that an artist, at least this artist, could not even contemplate the complete picture. Watteau's most beautiful paintings have a way of fading out before they quite reach the edges of the canvas, as if locking the painting too securely into the framing rectangle might be a false move, a gambit calculated to confound nature's unassailable freedom. Nature itself could suggest some idea or sensation of completeness, but Watteau understood that, for a creative spirit, completeness is a choice, a principle, an idea, an ideal that grows in the mind. Perhaps he believed that the artist who aims to include all of nature will tell us

more about his own craving for completeness than about completeness or, for that matter, about nature.

Watteau's gardens are all fragments, parts of some larger garden, bosky corners with overgrown paths that defy what we know to be the grand symmetries of French landscape design. He chose to render the part, to approach things from an angle, perhaps to sneak up on the possibility of completeness, but also to escape from the impossibility of doing it all. Working at the beginning of the eighteenth century, Watteau was a harbinger of the shifting tastes of the next two hundred years, of the fascination with the asymmetries of Asian art, with the peek, the glimpse. And although the idea of the vignette is most often associated with the nineteenth-century Romantics, it is Watteau, more than any other artist, who captured the poignant splendor of the part that can never be entirely separated from the whole. The vignette is by definition a fragment, something incomplete. In nineteenth-century illustrated books, the vignettes have no fixed borders, they are pictures, often landscapes, that simply fade away at the edges, and sometimes seem to fade directly into the accompanying text. They can suggest a vast realm, an entire universe, particularly in the hands of a master such as Turner, who created vignetted illustrations for books of poetry in the early nineteenth century.

Vignette, the word itself, has an interesting derivation, for it originally referred to the little ornamental decorations of vine leaves, tendrils, and grapes in medieval manuscripts. This returns us, through the very etymology of the word,

to the idea of the arabesque, the capriccio, the grotesque—and to Watteau. For you might say that every time Watteau drew a man or a woman he was creating a vignette, a little ornament at the margin of his life. And the beautiful sheets on which he scattered various studies of men and women can be regarded as gatherings or scatterings of vignettes, as beguiling in their randomness as the collages that anti-quarians liked to compose of the ornamental letters and arabesques they clipped from medieval manuscripts.

In Watteau's work you can feel the end of all the orderly cosmologies of the premodern world, and the gravity of the recognition is only underscored by the lightness of his touch, a touch that in the years after his death would become a defining characteristic of the rococo. Among the loveliest moments in the decorative and graphic arts of the eighteenth century are vignettes, whether on a fan, a coffee cup, or the page of an illustrated book. Let us consider one example, an illustration by Charles Eisen, who deserves to be known beyond the circles of bibliophiles who have always revered his delicate effects. Eisen offers a glimpse of rooftop and birds in flight, and the Asian simplicity of the view is amusingly enclosed in a pompous rococo frame. Here is a fragment of the world that invokes all sorts of pos-sibilities, as we are invited to look up, to look beyond, to watch the birds fly away. Certainly the origins of the vignette can be discovered deep in the eighteenth century, on fans and porcelains and in the pages of elegant volumes, but also in the sorts of wall decorations that Watteau painted early in his career, where amid the whirling callig-

Book illustration designed by Charles Eisen

raphy of architectural fantasy a couple, dancing or dreaming, often appears. The vignette destabilizes narrative, it fractures the panorama, and in this sense Watteau's art is above all else the art of the vignette, the art that celebrates the part because it is only the part that can come close to representing the whole.

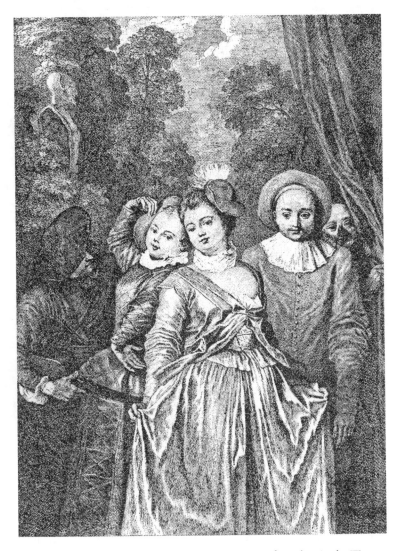

Print after a drawing by Watteau

W

Watteauesque. "There is something Watteauesque about the spirit of France, not only in the eighteenth century, but in earlier and later times as well." Louis Aragon offered this thought rather airily, rather vaguely, almost as if he were saying it to himself. Not that he was at all embarrassed to come out with such a grandiose and surely unprovable pronouncement. But he did worry that somebody might ask him to back it up, and that he might be at a loss for words. He was sitting next to Jean Cocteau, the two of them by now veterans of the literary battles of the twentieth century, and Cocteau never seemed to be at a loss for words, not that Aragon often was, either. They were together in Aragon's living room, a room heaped with books, vast piles of books, on the second floor of an ancient building not far from the Marché Saint-Honoré. Over a period of days—this was 1956—Cocteau had been walking the few blocks from his tiny apartment in the Palais Royal, so that he and Aragon could tape a series of conversations about the masterworks in the Dresden Gallery. The paintings had been removed during World War II, and were now on view again, in epochal exhibitions in Moscow and Dresden. Their conversation was careening from country to country, from century to century, they were two aesthetes

letting it rip, and after covering German painting and Italian painting at considerable length, they were glad to be back on home ground, with the French.

As they spoke into a tape recorder—it struck Cocteau as a contraption out of Kafka's *Castle*—their conversation was easy, affable, which would have surprised some of the people who had known them over the years. Aragon had been a central figure in André Breton's Surrealist movement, and the Surrealists had regarded Cocteau as the epitome of a fading aestheticism, on top of which Breton could not abide homosexuals. Later, during World War II, Cocteau had been on easy terms with the Nazis in Paris, friends with Hitler's favorite sculptor, Arno Breker, while Aragon had been immersed in the Resistance and had emerged as a celebrated poet of the fight to save France. Even now, in the mid-1950s, Aragon remained a central figure in the French Communist Party. But none of this seemed to matter that much to Aragon and Cocteau. Although neither was any longer young, they were both still energetic, both full of ideas and enthusiasms, both survivors, with the crackerjack energy that can last deep into middle age. And they were both men who could not live without the exhilaration of art, which had brought them together in Aragon's apartment, where they were sifting through a set of reproductions of the paintings in the Dresden Gallery.

But what of Watteau and the spirit of France? Could such a thing be described? What on earth did it mean? Of course nobody could really say, but perhaps Cocteau was getting at it when, looking at Watteau's *Garden Party*, with

nine or ten figures gathered around a long, stone bench, he spoke of "the amount of suppressed violence in Watteau's hazy atmosphere, the powerful grip underlying that elegance—a grace that relates to the darker side of Courbet." Watteau, Cocteau pursued, "lays a trap for the unwary. There's something terrifying about his gracefulness—a sadistic charm." Perhaps it was clichéd to argue that there was this cruelty beneath the shimmering elegance of French culture; but Cocteau and Aragon brought such quickening wit to their conversation that the clichés were turned back into truths, at least while they were talking. They were writers who often operated at the edge of profundity, making assertions that were not quite deep enough or perhaps too self-consciously deep to be truly profound. They had both pursued greatness with a feverish energy, and perhaps it was a relief to be involved in this project that demanded nothing more than that they be terrific conversationalists. This was the easiest thing in the world, at least for them. Watteau's work, so Cocteau pursued, "is suffused with this wig-powder cloudiness, and all that smoky beauty somehow predicts the storm to come. The people at those parties of Watteau's are like people coming together as a result of a railway accident, or during a halt or bombardment when they have left their cars on the road." It was just like Cocteau, the master of the metaphoric flourish, to turn Watteau's paintings into absurdist dramas, the sort of thing you would have seen on the Parisian stage in the years after World War II.

"You're absolutely right," Aragon jumped in. "There's

so much that's troubling and troublesome in Watteau's work. You know Watteau did some war scenes. Watteau was a witness or reporter, among other things. When he was on his way home from Paris, traveling on foot at the time of the battle of Malplaquet, he saw the defeat of the French army and recorded the retreat. In his drawings and in several paintings he interpreted the scenes of disorder, the evacuations, halts, temporary camps. And I've always felt that his interest in these scenes of camp life affected his later paintings of garden parties and amorous picnics. I think that Watteau's elegant young men and women are always to some degree assaulted by a sense of the uncertainty or aimlessness of life, a sense that is of course overpowering in times of war, but can be strong in peaceful times as well. Looking at Watteau's pastoral paintings I sometimes get the feeling that the young men and women have come together by chance, that some of them were bound for somewhere else and accidentally found themselves in this park, that they are not quite sure why they ended up here."

Then Aragon paused for a moment. He didn't know where to go with this. So he changed directions. "On the whole Watteau is my favorite French painter, and for many reasons. Do you know that extraordinary work, the album of Watteau's drawings, many of them engraved by the youthful Boucher?"—he was referring to *Les Figures de différents caractères*. "Of course," Cocteau replied. "In that album," Aragon pursued, "you see Watteau's first reactions to life, you see the personalities he later painted into his pictures. You see these people exactly as he did, the Italian

actors of the Hôtel de Bourgogne, just as they were in real life before taking on the unrealness of color. These are drawings of absolute precision, people you really meet, far more accurate than Daumier, for instance, and I'm not saying that lightly. They are really people as you see them at work, at play. Like Daumier's people in a railway carriage Watteau's figures are caught in the midst of a daydream, but it is a daydream infinitely superior to Daumier's, for Watteau gives the dream a stirring reality."

And then Cocteau pressed on. "Exactly. With Watteau, dreams are realities. His men and women wear their satin coats and dresses, all their ruffles and frills and flounces, as if each costume were a suit of armor. These men and women are armored in satins. Their charm isn't mere charm, it's an almost medieval charm, for Watteau restores to charm its original, medieval meaning, charm as the enchantment of a magic spell. This is a tough, dangerous charm, a charm that can change everything. Mezzetin, singing and playing his guitar, is casting a spell."

White. White equals possibility—the white paper to write on or draw on or compose on, the white canvas to paint on, but also the white of the empty gallery and the empty stage. For artists, this is the deep, primitive fascination of the white clown, whether Pierrot or Pulcinella or Gilles. Witness Watteau's *Gilles*, the clown who stands poker-faced in his costume. He is the archetype of the artist as pure potentiality, so purely potential that he strikes us as utterly enigmatic, essentially anxious, weirdly egotistical—

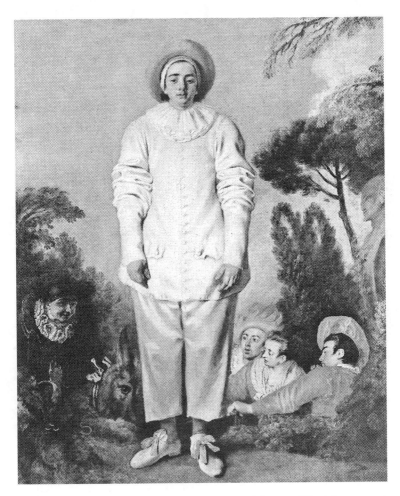

Watteau, *Gilles* (oil on canvas)

the artist who has nothing but the mad certainty of his convictions to guide him. The white of his costume—a muted white, an ivory white—is a great, open expanse, roughly rectangular in shape, dominating the painting, so that the figure itself becomes a tabula rasa, a bare canvas or

bare stage or sheet of paper, a place where nothing has yet happened but anything and everything can and will happen.

Gilles is raising a question about the possibilities of creation. How can I move from the nothingness of a beginning to the completeness of a work of art? Picasso, in one of his many paintings of Pierrot, a composition from 1918, underscores this idea of the white costume as a work of art in the making in the most literal way imaginable, by enlivening the white cloth with little rivulets and explosions of highly charged color, as if to say that Pierrot is a blank canvas that we are watching in the very process of being painted. It is often observed that there is something passive about the clown dressed all in white, but if so, this passivity is close to the receptivity of the true artistic spirit. The painting of Gilles, as Erwin Panofsky once remarked, is a "self-revelation." The quizzical, uneasy look on the clown's face is the look of the work of art that is not yet created, that is still wondering what it will be. You might even argue that the white clown, whether Pierrot or Gilles or Pulcinella on the one hand, and Harlequin on the other, forms an allegory of the beginnings and ends of art. For if the white costume is all possibility, the Harlequin's costume, with its tightly geometricized patterning and form-fitting tailoring, is art in all its completeness, all its thoroughness—art in its definitive state.

Women. Katharine Hepburn in *Bringing Up Baby* is the most recent incarnation of the Watteau woman, a woman

who is gorgeous and funny and sexy and independent. Hepburn is not weighed down by the awareness of her beauty. Her high cheekbones and long neck and flashing eyes only embolden her, liberate her. She may be neurotic, surely she is neurotic, but she is at play in her neuroses, she has the artfulness to do battle with her demons. She goes her own way, she thinks her own thoughts. She slips through the snares of love and marriage and children and hearth and home, so thoroughly female that nobody would ever deny she was capable of all that. And the great stream of her conversation, conversation shot off so quickly in that almost comically refined accent that you can hardly imagine how it is done, keeps the traditional feminine possibilities floating in the air, delightful options set aside, but perhaps only for the moment, like balls kept high in the air by the most brilliant juggler.

Especially in the first half hour or so of *Bringing Up Baby*, Hepburn is all quicksilver hilarity, a wild fantasy of feminine freedom, as unpredictable as Baby, her pet leopard. I would not care to draw a straight line from Watteau's women to what is perhaps Howard Hawks's greatest movie, but there is nevertheless something in Hawks's comedy that carries us back to Watteau. Watteau's women were the first who refused to be defined by others, at least in any conventional way, so much so that the refusal became, for Watteau, the definition of a new kind of woman, a woman who stood apart from the conventional roles. In some of Watteau's drawings, an ethereal yet earthy woman, a fully clothed visitor to the studio, is almost sprawled on the floor. The pose suggests the first bohemians in the history of art, and some-

times a leopard hungrily pawing the ground. There is an audacity about the poses in these drawings, and we can easily imagine that any minute now the woman is going to take it all off. But Watteau's women, while never foreclosing the possibility of sex, prefer to leave it in the realm of possibility. They may worry about what some will perceive as their inability to make a decision, but they have found that indecision can armor them against life's confusions—they have become experts in the art of indecision. The truth is that these delicately beautiful women like to leave just about everything in the realm of possibility. Sex, marriage, children, hearth and home—these are ideas, alternatives,

Detail from a drawing by Watteau (chalk on paper)

options that they choose to keep at arm's length. They don't reject them, but they don't accept them, either. They may toy with one or another role, almost absent-mindedly stroking the head of a child who's playing at their feet. They consider love, marriage, children. And then they whirl away again, full of feeling and yet somehow untouchable.

Watteau's women do not care to represent Womanhood or Love or Beauty, certainly not with a capital W or L or B. They are not the sort of women who want to be regarded as forces of nature. They are not interested in being idealized or idolized. They are too much at ease to be caught up in such fantasies. They stand apart from their own beauty and their amorous adventures, as if they felt free to consider the value of love or beauty, but only the value it might have for them, for now—a private matter. They are in some sense natural aristocrats, with a freedom from social constraints that gives them the aura of supernatural beings, even of goddesses. (As, indeed, Hepburn can feel like a madcap goddess in *Bringing Up Baby*.) But Watteau's women are not goddesses in any classical sense. They have none of the traditional responsibilities of goddesses. They do not personify some value or virtue. They do not have supernatural powers. And that is precisely their charm, the key to their comic exuberance. They are goddesses who are freed from all responsibility. They are goddesses who have resigned from their roles. They are goddesses on the lam.

X

X-shape. There is no such thing as a painting without an underlying geometry, for geometry is there in the shape of the canvas, in the bare fact of the rectangular support—the simplicity of the ☐ . From this bare fact a range of pictorial geometries have been derived, divisions and subdivisions in all their dizzying variety, golden rectangles, or tessellations, or perspectival systems that subdivide the surface in such a way as to suggest fictive depths. Watteau, however, does not really care for any of these more or less elaborate systems; he prefers to regard geometry as an improvisation, so that his most frequent response to the rectangular support is the quickening suggestion of an X-shape, the suggestion of two lines of force, one running from the lower left corner of the canvas to the upper right, the other from the lower right corner to the upper left: ☒ .

Of course Watteau doesn't like to present this great X as a violent assertion. His X has the echoing mysteriousness of a whisper, iconographic yet sub rosa. His men and women feel the pressure of the X-shape, and frequently fall into its rhythms, although not by any means all the time. The gesture of an arm or a leg or a head will echo or underline one of those two lines of force. And at times the groups of gathered figures compose themselves in angles and trajectories

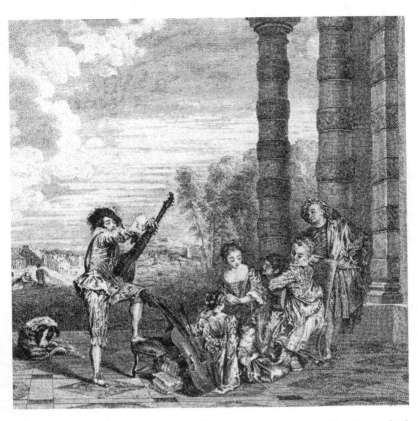

Detail from a print after Watteau, *The Charms of Life*

that accord with the hieratic X. For Watteau, the X-shape suggests three-dimensional experience, but also the denial of three-dimensional space. In the lower part of the canvas a diagonal almost inevitably suggests the promise of deep space: ⬚. But in the upper part of the canvas the X confounds space, because if the center of the X indicates the horizon line, the rising X carries us back to the surface,

locks that horizon back into the upper corners of the canvas: . Thus the X-shape, mere child's play in some sense, is really an enigma, a giving of space and a taking away of space. It is also, in spite of its cool geometry, the first act of rebellion against the decorous verticality and horizontality of the rectangle, an introduction of the extremism of angles, related to the parti-colored costume of the mischievous man who leads the harlequinade. Watteau's X is nothing like the X on a treasure map, for it is not the key that unlocks a mystery so much as it is itself the embodiment of a mystery.

Y

Youth. How old are the pleasure seekers in Watteau's paintings? It is not always easy to say. I would guess they are by and large somewhere between their twenties and their thirties, though a few might be teenagers who have leapt into the physical ease of adulthood. In any event, we

Print after a design by Watteau

are held by their youth even when we regard it with a sort of ironic skepticism. These men and women represent the imperishableness of youth, with all its wild appetites. They also suggest the gleeful, unexamined egotism that so often brings the young such terrible despair, and that we regret when we've lost it, and that at any time in life can seize us again, a dumb, inexplicable feeling, unmeasured, unmediated, a torture and a tonic. Whatever the ages of these men and women, they have the agile muscles, the mingling of quickness, slowness, dreaminess, vagueness, eagerness, wildness, shyness, abashedness, and unabashedness that we associate with youth. They have the speculative energies, the scrambled attributes of the young, of that period in a person's life when personality is still an improvisation, often a painful improvisation. And they also suggest the triumphant confidence of youth, the moment when the flirtation begins to give way to a story, when the couple with their dark hair and dark eyes, two individuals so beautiful in mind and matter that only Watteau could do them justice, propose to intertwine the intricacies of their exquisite hearts.

Detail from a print after Watteau, *Gersaint's Shopsign*

Z

Zeuxis. Although there had been painters for thousands of years before the ancient Greeks began to limn figures and landscapes and still lifes on walls and panels and ceramics, the Greeks were the first painters to whom history has attached names, lives, and myths. Zeuxis is often said to have been a master of atmosphere, of sunlight and shadow, famous for a study of a centaur family, which was perhaps a primeval pastoral. Of course none of his paintings any longer exist. Even by Roman times they were mostly the stuff of legend. But the accounts that have come down to us of the work of Zeuxis and Apelles and the other Greek painters have their own kind of interest, for they contain some of the first recorded discussions of the nature of pictorial art and illusion. Although many of us will always associate painting with the works that we see in gold frames in museums, the truth is that before there were paintings there was the magic of paint itself, the humble alchemy that Gertrude Stein alluded to in one of the lectures she gave in the 1930s, when she said that "I like to look at anything painted in oil on a flat surface." And wasn't it that same alchemy, only in an infinitely more refined form, that astonished the Greeks in the work of Apelles and Zeuxis?

I first felt painting's primal power when I was five or six

years old, during the weeks I spent in my grandparents' house in Brooklyn. It was a brick house, freestanding in a neighborhood where most of the houses were attached to one another, a house to which my mother's parents had only recently moved, after living for decades in an apartment over the store where my grandfather sold fur coats. For them this was a big step up in the world. The house was a mid-century version of a traditional home, with an entry hall that framed a staircase, a formal dining room to the left, a living room to the right. And to my young, eager eyes, the traditionalism of my grandparents' house had a particular fascination, an almost freakish fascination. I was accustomed to the austere modern style of the apartments where I was growing up, for my parents, who were in the academic world, favored modular black lacquer furniture, walls painted a single flat color, and a few reproductions of paintings by Picasso and Vermeer. For me the slightly coarse flamboyance of my grandparents' new house had the allure of the unfamiliar. In the dining room there was a huge, dark breakfront, with china in the glass-fronted top cabinet and a few bottles of liquor in the cabinet below. The furniture in the living room was covered in a heavy brocade. And in the finished basement there was a rather elaborate bar outfitted with mirrors, on which stood the ornament from my parents' wedding cake.

But what really held me about my grandparents' new house were the interior walls and moldings, which had been painted by a man who was skilled in the art of decorative surfaces and finishes. I was fascinated by the things that this

Brooklynite could do with his brushes. I loved the illusions he created. And I sensed, without of course being able to articulate what I was feeling, that what I was encountering was nothing less than a recapitulation of the origins of painting. The work that amazed me the most was the treatment of the woodwork, for the doors and doorframes and staircase of my grandparents' house, although made of wood, had been painted to imitate wood. I was too young to know anything about Cubist collage, or that Braque had been trained to paint faux wood grain, just like the man who painted my grandparents' house. But I was nonetheless mesmerized by the double entendre of wood that had been covered with paint only to be painted to imitate wood. I count this my first lesson in the charms of illusionism. And it is a lesson that I've never forgotten. There were other wonders. One of the upstairs bedrooms had been painted to imitate plaid wallpaper. I sometimes stayed in that room, and I would look ever so closely at those walls, running my fingers over them, astonished at the playfulness of the illusion. Across the hall, in my grandparents' bedroom, deep pink, dusky roses were painted along the ceiling and framed a little alcove where my grandmother had her vanity table. They were crude, ugly roses, and yet I could sense that I was encountering—again, without being able to articulate it—the last, horrific gasp of the rococo.

And then there was, painted on a wall in the living room, above the couch, a classical vista. This contained, if I remember correctly, a lake, some trees, and a circular temple. It was not much of a painting, but it was enough to

puncture the flatness of the wall and in doing so create the feeble suggestion of an imaginary world. It seems to me now that whenever I came to New York to visit my grandparents, I would come down with a sore throat. And when that happened I found myself spending entire weekday afternoons sitting in a deep upholstered armchair in the living room, gorging on daytime TV. My parents were the sort of intellectuals who were suspicious of TV, we didn't have one at home, which made these afternoons at my grandparents' all the more a guilty pleasure. And from time to time, when whatever program I was watching was too boring to bear, I would look over at the far side of the room, at the brocaded couch and, above it, that painted landscape. It was pale and indistinct, a distant descendant of all the romantic vistas in Western art, a dime-store pastoral, concocted by a housepainter who was paid by the hour or the day or the job. And yet I was charmed, charmed by what I now realize was a down-market Cythera. It was a Cythera without occupants—a lonely, fascinating place.

Perhaps the pilgrims would soon arrive. Perhaps they had already come and gone. But none of this really mattered. It was the palpability of that impalpable painted world that held me in its gentle yet forceful grip. Even then, even there, I was mesmerized by painting's dreams—and by all the dreamworlds and real worlds that painting could reveal. And this is where I have remained ever since, much like the men and women in Watteau's *Pilgrimage to the Isle of Cythera,* unsure as to whether I am coming or going, but always convinced that the journey matters, that love and

friendship and beauty and pleasure can be found amid the
darkening groves, if only I am willing to grasp that hand or
look into that face or talk to that person, and let the possibil-
ities unfurl beneath the cloud-scattered skies.

Acknowledgments

Deborah Rosenthal and I had been looking at Watteau and talking about Watteau long before our unforgettable 1980 trip to Paris. *Antoine's Alphabet* would not exist without Deborah's unrivaled painter's eye.

Carol Brown Janeway is a tremendous editor and a wonderful friend. I have come to depend on her steadiness of purpose, her quickening imagination, her sense of fun.

I want to express my deep gratitude to Nathan Perl-Rosenthal, Jessie Marglin, Leon Wieseltier, Jennifer Lyons, and Martin Schulman. Douglas Crase and Nick Lyons generously read the entire manuscript and made valuable comments. Colin Bailey was kind enough to review the page proofs, bringing a scholar's perspective.

I very much appreciate Anthea Lingeman's beautiful design, Peter Mendelsund's superb cover, Ellen Feldman's attention to the manuscript, and Roméo Enriquez's work on the reproductions. Thanks also to Lauren LeBlanc, Katherine Hourigan, Lydia Buechler, Andy Hughes, and Iris Weinstein.

I would like to single out a number of books that have been important, and also acknowledge Nathan Perl-Rosenthal's help with various points of French history. The catalog of the 1984–85 retrospective *Watteau: 1684–1721*, edited by Margaret Morgan Grasselli and Pierre Rosenberg (Washington, D.C.:

National Gallery of Art, 1984), has been invaluable. Rosenberg's entries on Watteau's paintings are both heartfelt and precise. The eighteenth-century texts on Watteau are collected in *Vies anciennes de Watteau*, also edited by Rosenberg (Paris: Hermann, 1984). For a range of views, see the volume that grew out of the conference held at the time of the 1984 retrospective: François Moureau and Margaret Morgan Grasselli, editors, *Antoine Watteau (1684–1721) le peintre, son temps et sa légende* (Paris: Campion, 1987). Although I do not agree with Donald Posner's insistence on downplaying the wistfulness and melancholy of Watteau's work, his *Antoine Watteau* (Ithaca: Cornell University Press, 1984) remains immensely useful. An exemplary study of a single painting is Edgar Munhall's *Little Notes Concerning Watteau's* Portal of Valenciennes (New York: The Frick Collection, 1992). Among other recent studies of Watteau, I would mention Sarah R. Cohen's valuable *Art, Dance, and the Body in the French Culture of the Ancien Régime* (Cambridge: Cambridge University Press, 2000), as well as Julie Anne Plax, *Watteau and the Cultural Politics of Eighteenth-Century France* (Cambridge: Cambridge University Press, 2000), and Mary Vidal, *Watteau's Painted Conversations: Art, Literature, and Talk in Seventeenth- and Eighteenth-Century France* (New Haven: Yale University Press, 1992). At one point I had thought to say more about recent works of fiction in which Watteau and his work figure; they include Philippe Sollers's *La fête à Venise*, which appeared in English as *Watteau in Venice*, translation by Alberto Manguel (New York: Charles Scribner's Sons, 1994), and Pierre Michon's *Maîtres et serviteurs*, translated as *Masters and Servants* by Wyatt Mason (San Francisco: Mer-

cury House, 1997). A good place to begin a study of the pastoral tradition in the visual arts is with *Places of Delight: The Pastoral Landscape*, edited by Robert Cafritz (New York: Clarkson N. Potter, 1988), and *The Pastoral Landscape*, edited by John Dixon Hunt (Washington, D.C.: National Gallery of Art, 1992). Among the finest studies of the place of Watteau and Pierrot in nineteenth-century culture are two by Louisa E. Jones: *Pierrot-Watteau: A Nineteenth-Century Myth* (Paris: Editions Jean-Michel Place, 1984) and *Sad Clowns and Pale Pierrots: Literature and the Popular Arts in Nineteenth-Century France* (Lexington, Ky.: French Forum, Publishers, 1984). The conversation between Louis Aragon and Jean Cocteau is based on Louis Aragon and Jean Cocteau, *Conversations on the Dresden Gallery*, translation by Francis Scarfe (New York: Holmes & Meier, 1982).

Many of the illustrations in this book are derived from eighteenth-century prints. Most of the prints after drawings come from *Les Figures de différents caractères*, published in two volumes in 1726 and 1728. The many prints after Watteau's paintings are collected in Émile Dacier and Albert Vuaflart, *Jean de Jullienne et les graveurs de Watteau au XVIIIe siècle* (Paris: La Société pour l'étude de la gravure française, 1929). In the prints after paintings, the compositions are generally reversed. The paintings not reproduced in the form of prints are *Mezzetin* (Metropolitan Museum of Art, New York), *The Judgment of Paris* (Louvre, Paris), and *Gilles* (Louvre, Paris).

Permissions Acknowledgments

Grateful acknowledgment is made to the following for
permission to reprint previously published material:

Holmes & Meier Publishers, Inc.: Conversation between
Louis Aragon and Jean Cocteau from *Conversations on
the Dresden Gallery* by Louis Aragon and Jean Cocteau,
translated by Francis Scarfe, copyright © 1982 by
Holmes & Meier Publishers, Inc. (New York: Holmes &
Meier, 1982). Adapted here by permission of Holmes &
Meier Publishers, Inc.

Liveright Publishing Corporation: Excerpt from "any
man is wonderful" from *Complete Poems: 1904–1962* by
E. E. Cummings, edited by Geroge J. Firmage,
copyright © 1923, 1951, 1991 by the Trustees for the
E. E. Cummings Trust. Copyright © 1976 by George
James Firmage. Reprinted by permission of Liveright
Publishing Corporation.

New Directions Publishing Corp.: Excerpt from "A
Girl" from *Personae* by Ezra Pound, copyright © 1926
by Ezra Pound. Reprinted by permission of
New Directions Publishing Corp.

ALSO BY JED PERL

"A thrilling achievement." —The Atlantic Monthly

NEW ART CITY
Manhattan at Mid-Century

In this landmark work, Jed Perl captures the excitement of a generation of legendary artists—Jackson Pollack, Joseph Cornell, Robert Rauschenberg, and Ellsworth Kelly among them—who came to New York, mingled in its lofts and bars, and revolutionized American art. In a continuously arresting narrative, Perl also portrays such less well known figures as the galvanic teacher Hans Hofmann, the lyric expressionist Joan Mitchell, and the adventuresome realist Fairfield Porter, as well the writers, critics, and patrons who rounded out the artists' world. Brilliantly describing the intellectual crosscurrents of the time as well as the genius of dozens of artists, *New Art City* is indispensable for lovers of modern art and culture.

Art History/Criticism/978-1-4000-3465-9

Printed in the United States
by Baker & Taylor Publisher Services